Benjamin Brecknell Turner

Rural England through a Victorian Lens

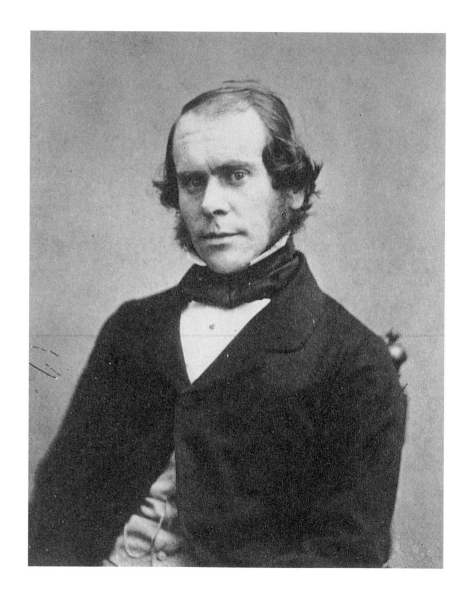

B.B.Turner: Self-Portrait, 1850s

Benjamin Brecknell Turner

Rural England through a Victorian Lens

Martin Barnes

Introduction by Malcolm Daniel

Biography by Mark Haworth-Booth

V&A PUBLICATIONS

Distributed by Harry N. Abrams, Inc., Publishers

First published by V&A Publications, 2001
V&A Publications
160 Brompton Road
London SW3 1HW
© The Board of Trustees of the Victoria and Albert Museum 2001

Martin Barnes and all the contributors to this book assert their moral right to be identified as the authors

Distributed in North America by Harry N. Abrams, Incorporated, New York
ISBN 0-8109-6583-6
(Harry N. Abrams, Inc.)

Designed by Roger Davies+Gregory Taylor (www.rogerdaviesdesign.co.uk)
V&A photography by Ken Jackson, V&A Photography Studio

Every effort has been made to seek permission to reproduce those images whose copyright does not reside with the V&A, and we are grateful to the individuals and institutions who have assisted in this task. Any omissions are entirely unintentional, and the details should be addressed to the publishers.

Originated by Colorlito S.r.l.
Printed in Italy by Grafiche Milani

Front jacket illustration: Hawkhurst Church
Back jacket illustration: Crystal Palace, Hyde Park, 1852. Transept
Introduction opener: Detail of plate 32
Biography opener: Detail of plate 46
Photographic Views from Nature opener: Detail of plate 7
Plates opener: Detail of plate 41

The titles of the figures in the text in italics are those given by the artist; those in the regular font are descriptive.

The Canon Photography Gallery at the V&A and its five-year display programme, including *Rural England through a Victorian Lens: Benjamin Brecknall Turner*, are sponsored by Canon.

Harry N. Abrams Inc.
100 Fifth Avenue
New York, N.Y. 10011
www.abramsbooks.com

Acknowledgements

Much of the writing of this book depended upon assistance, information and advice freely given by my colleagues at the Victoria and Albert Museum, particularly: Malcolm Baker, Geoff Barlow, Guy Baxter, Kate Best, Jane Buller, Mary Butler, Charlotte Cotton, Clare Davis, Mark Evans, Alison Hadfield, Miranda Harrison, Ken Jackson, Christopher Marsden, Elizabeth Martin, Elizabeth Miller, Charles Newton, Frances Rankine, Pascale Regnault, Michael Snodin, Margaret Timmers and Mary Wessel.

I have received valuable support from colleagues in other museums and archives including: Tim Bridges at The Worcestershire City Museum and Art Gallery; Nicole Burnett at The Museum of Local Life, Worcester; Anita Blythe and Robin Hill at Worcester County Museum; Jenny Childs at the Worcester Record Office; Sara Rodger at Arundel Castle, Sussex; Jonathan Brown at The Rural History Centre and Museum of English Rural Life, Reading; Philip Atkins at The National Railway Museum, York; Brian Liddy and Colin Harding at The National Museum of Photography Film and Television, Bradford; Claire Bertrand, Vikki Hill, Samantha Johnson and Pamela Roberts at The Royal Photographic Society, Bath; Duncan Forbes at The Scottish National Portrait Gallery, Edinburgh; Barry Chandler at Torquay Museum; Helen Gray at The Royal Archive, Windsor; Hazel M. Mackenzie at The National Gallery of Canada, Ottawa; Maria Antonella Pelizzari at the Canadian Centre for Architecture, Montreal; Roy Flukinger and Mary Alice Harper at The Harry Ransom Humanities Research Center, University of Texas, Austin; Julian Cox and Mikka Gee at the J. Paul Getty Museum, Los Angeles; Michael Wilson and Violet Hamilton, the Wilson Family collection; Anneke van Veen at the Gemeentearchief, Amsterdam; Mattie Boom and Hans Rooseboom at the Rijksmuseum, Amsterdam; and Saskia Asser at the Huis Marseilles Foundation for Photography, Amsterdam.

Many individuals have shared their knowledge and enthusiasm along the way. I am grateful to: Erica Bemporad, Ianthe Carswell, Roger Davies, Juliet Hacking, John Hemingway, Gill Hollis, Moira Johnston, Eloy Koldeweij, Robert Lassam, Penny Martin, Michael More-Molyneux, John Murdoch, Margaret Orton, Phillip Prodger, Kathleen Robinson, Larry J. Schaaf, Ron Sears, Roger Taylor, John Ward and Mike Weaver. I am especially grateful to my friend Christopher Whitehead for his insightful comments on my text and to Malcolm Daniel and Mark Haworth-Booth for an inspiring and enriching collaboration. I am indebted to Imke Valentien and the Barnes family – Brian, Josephine and Claire – for nurturing and sharing over the years an interest in following the smaller 'B' roads that lead to the quiet places of England.
 M.B.

Contents

Chronology of Benjamin Brecknell Turner's Life

1815	Born in London.
1831	Leaves Queen Elizabeth's Old Palace School, Enfield, London at the age of sixteen to join the family tallow chandlers (candle and saddle soap manufacturing) business.
1840	Travels to Belgium, Switzerland and Paris.
1845	Travels to Switzerland, Munich, Salzburg, Vienna, Prague, Dresden, Berlin and Hamburg.
1847	Lives above the business premises in the Haymarket, London. Marries Agnes Chamberlain, the daughter of Henry Chamberlain, formerly a Worcester China manufacturer who bought Bredicot Court, four miles outside Worcester, in 1836.
1849	Takes out a licence from William Henry Fox Talbot to practise Talbot's patented photographic process.
1852	Photographs the interior of Crystal Palace in Hyde Park, London. Exhibits six photographs at the Society of Arts, London.
1853	Founder-member of the Photographic Society of London.
1854	Exhibits eight photographs in the Photographic Society Exhibition, London.
1855	Contributes to The Photographic Album for the Year 1855. Exhibits eleven photographs at the Photographic Society Exhibition, London. Receives bronze medal, Exposition Universelle, Paris.
1856	Exhibits two photographs at the Photographic Society Exhibition, Norwich.
1857	Photographs in Amsterdam. Exhibits six photographs at Manchester.
1858	Exhibits eight photographs at the Photographic Society Exhibition, London.
1859	Exhibits seven photographs at the Photographic Society Exhibition, Glasgow, and eight photographs at the Photographic Society Exhibition, London.
1860	Volunteers to be an ensign in the Queen's Westminster's regiment.
1862	Resigns from the Queen's Westminster's. Exhibits nine photographs at the International Exhibition, London.
1864	Moves from the Haymarket to Tulse Hill, south London.
1873	Becomes concerned about the decline in tallow chandler business and moves to a smaller house in Tulse Hill.
1887	Agnes Turner dies.
1894	Dies in London.

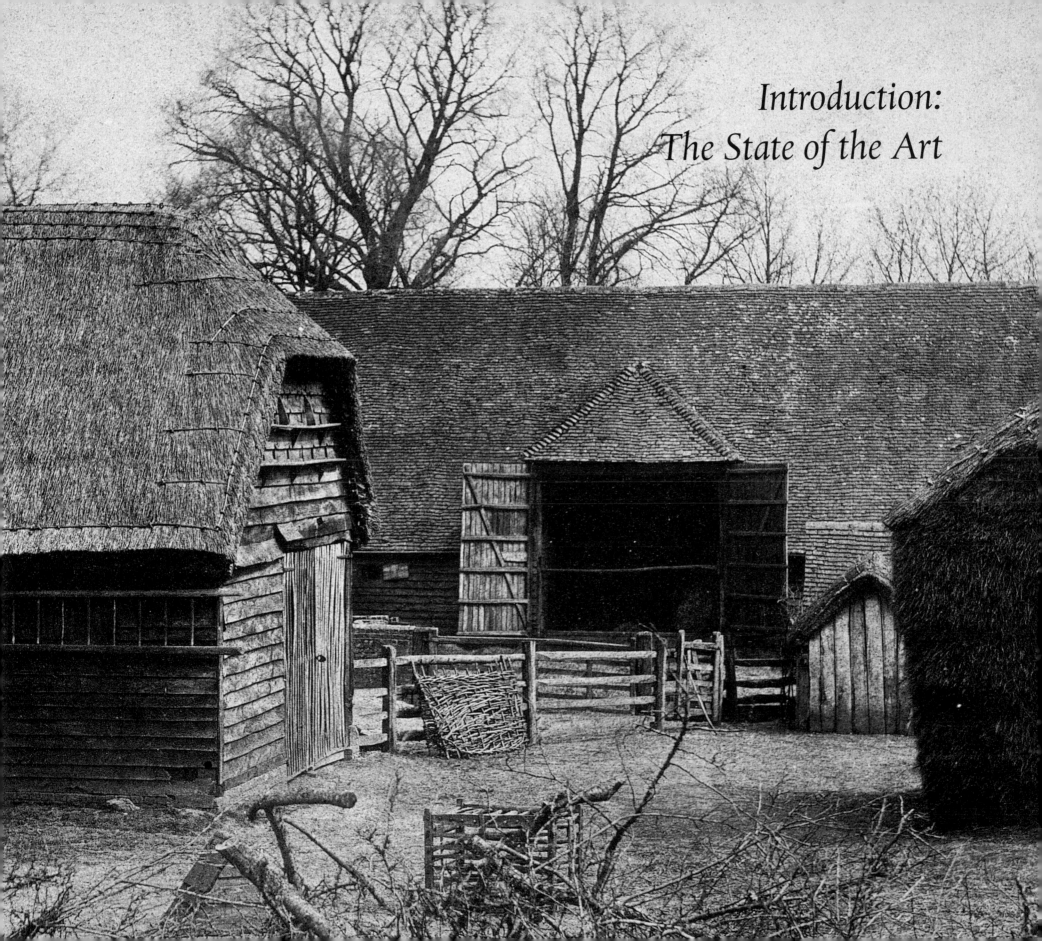

Introduction: The State of the Art

Malcolm Daniel

Touring the West Midlands of England, you may chance upon the small village of Bredicot several miles east of Worcester – little more, even now, than a few cottages and an old half-timbered house that was once the holiday retreat of a Victorian businessman and amateur photographer, Benjamin Brecknell Turner. As you take your camera from your bag – perhaps a disposable point-and-shoot or a new digital camera that will make it easy to e-mail a copy of the image to your friends – you might ponder for a moment the state of the art when B.B. Turner set up *his* camera some 150 years ago to record the character of this same humble hamlet.

Turner worked at a time when photographs were still handcrafted and when successful results depended as much on seat-of-the-pants judgment as on standardised materials and codified procedures; photography was cuisine as much as science. Despite improvements, the camera itself was still a 'clumsy, unmanageable affair',[1] huge and heavy. In the absence of a practical means of enlarging, prints the size of Turner's mature work – nearly 12 × 16 inches (about 30 × 40 cm) – required negatives just as large, and they in turn demanded a camera of enormous proportions. His negatives were made of fine paper, and each sheet had to be prepared by hand, first brushed with a solution of salt and later sensitised in a bath of silver nitrate. Far from the instantaneity we are now accustomed to, Turner's exposures lasted a half-hour even on the brightest days, and each positive from the finished negative took nearly as long to print in the sun. The amount of labour involved in producing each photograph naturally encouraged careful consideration.

Turner first practised photography in 1849, when it was still largely the province of gentlemen amateurs – generally men of education, means and social position – who took up the new medium as others might take up watercolours, and who turned their artistic and intellectual curiosity towards the pleasant task of photographing their families, friends, homes and, eventually, surrounding landscapes. It was a passion, not a profession.

Like most paper photographs of the time, Turner's early works, from 1849 to 1851, were modest pictures of domestic life, usually no larger than 6 × 8 inches (15.2 × 20.3 cm). Beginning in 1852, however, Turner's photographic skill and ambition surged forward, and his photographs became large, complex and impressive, commanding attention even now. Turner's transformation after 1851 is emblematic of a tidal shift in British photography, for although photography had burst on to the scientific and artistic stage more than a dozen years earlier, it was only at the Great Exhibition of

the Works of Industry of All Nations that many people discovered what it could do. Six million visitors marvelled at the exhibits in London's Crystal Palace, and many came away with an appetite whetted for this new medium. For British photographers the displays were both thrilling and sobering.

Predictably, daguerreotypes – one-of-a-kind photographic images on silver-plated sheets of copper – were produced with greater mastery and embraced by a larger public in France where the process was invented and in America where, as the jury at the Great Exhibition remarked (out of fairness to British artists), the photographer's 'every effort has been seconded by all that climate and the purest of atmospheres could effect'.[2] It was predictably so, for the French government had magnanimously presented the daguerreotype process to all the world, for the benefit of mankind, free of restrictions … except in England, where the inventor Louis Daguerre (1789-1851) had already taken out a patent. True, Antoine Claudet (a transplanted Frenchman) had purchased a licence, established a daguerreotype studio in London, perfected the process and produced acclaimed results, but the 'daguerreotypomania' that swept much of the rest of the world was relatively subdued in England.

More surprising and distressing, however, were the advances foreign artists had made in the field of paper photography, the invention of an Englishman, Henry Talbot (1800-77). Here, too, British artists discovered that they worked under a disadvantage, for while use of the patented Talbotype or calotype process still required the purchase of a licence in England, French photographers had tinkered with Talbot's recipes and procedures enough to circumvent his patent claims in the French courts. British photographers like Turner, whose use of the medium was avocational, could buy a Talbotype licence for one or two pounds, but for photographic professionals the licences could cost anywhere from £10 to £100 or more, and the patents stifled widespread use and experimentation.

Without fear of having their efforts blocked, the French had indeed made major advances on the original Talbotype process. While many photographers (Turner included) routinely waxed their finished calotype negatives for added translucency, Gustave Le Gray (1820-82) had introduced a step in which the paper was waxed prior to sensitising; his negatives could be prepared days ahead of time, and the resulting prints had far greater clarity because the photosensitive silver salts sat on the surface of his negatives rather than being absorbed by the paper fibres. In a still greater departure, Abel Niépce de Saint-Victor achieved near perfect resolution by using

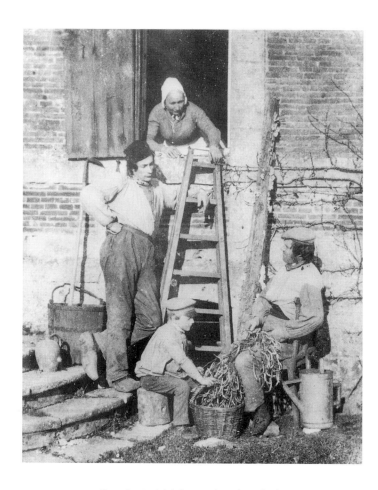

Fig. 1 Louis-Adolphe Humbert de Molard
Stringing Beans, 1851
Salted paper print from paper negative
8¾ × 7 in (22.2 × 17.8 cm)
Gilman Paper Company Collection, New York

glass rather than paper as his support and by coating it with a layer of egg white which he then sensitised with silver salts. And Louis-Désiré Blanquart-Evrard made the mass production of photographic prints commercially viable by applying to positives as well as to negatives Talbot's technique of developing-out a latent image.

In the wake of the Great Exhibition, British photographers increasingly pressed Talbot to cede his patent rights, eventually enlisting the support of notable men of science and art including Sir John Herschel, Lord Rosse and Sir Charles Eastlake, president of the Royal Academy and director of the National Gallery. Appealing to the inventor's pride and nationalism, Rosse and Eastlake wrote: 'As the art itself originated in England, it should also receive its further perfection and development in this country. At present, however, although England continues to take the lead in some branches of the art, yet in others the French are unquestionably making more rapid progress than we are.'[3]

By the end of 1852, the climate for photography in Great Britain had begun to change radically. Talbot withdrew his restrictions in July (except in the case of professional portraiture), and British photographers organised a photography exhibition at the Society of Arts that December and founded a photographic society and journal in the following months. Equally dramatic was a breakthrough in photographic technology – Frederick Scott Archer's process of wet-collodion-on-glass negatives, which successfully combined the precision of the daguerreotype and the reproducibility of the Talbotype. Archer's process allowed exposures that could be counted in seconds rather than minutes and produced sharp and luminous prints. Although it may not yet have been fully clear by the time of the Great Exhibition (Archer published his process in *The Chemist* in March 1851), this is where the future lay. Debate over the relative merits of paper and glass was lively in the early 1850s, but wet-collodion negatives rapidly displaced paper and dominated the medium for three decades.

Although Turner kept abreast of these developments, clipped articles that detailed improvements to both paper and glass negative processes and even tried his hand at the wet-collodion technique, he remained a steadfast adherent of the original Talbotype process throughout the 1850s, an aesthetic choice that risked being characterised as retrograde. One correspondent to the *Journal of the Photographic Society* the year Turner compiled his *Photographic Views from Nature,* for example, declared the paper negative incapable of yielding sufficiently developed half tones, 'a defect greatly to be deplored, inasmuch, as in the preservation of half tint consists the excellency of

Fig. 2 V. Dijon
Farmyard Scene, early 1850s
Albumen silver print from paper negative
10⅝ × 11¾ in (27 × 29.9 cm)
The Metropolitan Museum of Art, New York; Purchase, The Horace
W. Goldsmith Foundation Gift, Samuel J. Wagstaff, Jr Bequest, and
Pfeiffer Fund 1993 (1993.70)

every work of art, be it a painting or a photograph'. A paper negative, he wrote, 'will never give you anything but soot for shadows and whitewash for lights.'[4] But Turner's choice was deliberate, for in his hands the paper negative yielded prints that were graphically strong and that conveyed a solidity and grittiness appropriate to his favoured subjects of farmyards, trees and ruins.

Turner's pictures are unmistakably English, a character evident in his choice of subject matter. In remarks about the Society of Arts exhibition, Turner's colleague Roger Fenton (1819-69) noted that 'The French pictures are of cities, fortresses, churches, palaces,– the living triumphs or the decaying monuments of man's genius and pride'. By contrast, and as if describing Turner's submissions in particular, Fenton described the English pictures as more rooted in a pastoral tradition that focused on the 'peaceful village', 'gnarled oak', 'quiet stream' and 'tangled wood.'[5]

The English character of Turner's photographs, however, is apparent even in a comparison with French pictures of similar subjects by artists of similar circumstances. Louis-Adolphe Humbert de Molard (1800-74), for instance, might seem to be a parallel figure – a gentleman amateur who photographed scenes of rural life at his country estate in Normandy (fig. 1). Humbert de Molard, however, strove to create with his camera the type of genre scene he admired in seventeenth-century Dutch painting and its early nineteenth-century French revival. People, rarely present in Turner's work, are the central focus of Humbert de Molard's story, while the humble farm buildings, hayricks and wooden carts that are at the heart of Turner's pictures are mere stage sets and props for the French photographer.

Or, compare Turner's photograph of *Farmyard, Elfords, Hawkhurst* (pl. 26) with another French picture that might seem quite like it – the yard of a half-timbered, thatch-roofed barn, strewn with farm implements, all rendered, like Turner's, in a large albumen print from a paper negative (fig. 2). This photograph by V. Dijon, an amateur working in the region of Vichy, is a whirlwind of disorder and a patchwork of intense light and shadow. While suggesting the activities of rural life, Dijon's rakes, baskets, butter churns and buckets – the very things that in Turner's work would be the substance of the scene, the carriers of meaning – are primarily vehicles for chiaroscuro effect.

This tendency of the French to stress light and shadow – *effet*, as it was called in painting – over substance is evident again in a comparison of Turner's *Hedgerow Trees, Clerkenleap, Worcestershire* (plate 46) with Gustave Le Gray's more or less contempora-

Fig. 3 Gustave Le Gray
Oak and Rocks, Forest of Fontainebleau, 1849-52
Salted paper print from paper negative
9 $^{15}/_{16}$ × 14 $^{1}/_{16}$ in (25.2 × 35.7 cm)
The Metropolitan Museum of Art; Purchase, Jennifer and Joseph
Duke and Lila Acheson Wallace Gifts, 1999 (2000.13)

neous view of the Fontainebleau Forest (fig. 3). In Le Gray's photograph the network
of branches, patches of lichen and sparkling vegetation are intentionally woven
together to create an ambiguity between solid and void, substance and shadow. The
very qualities we now admire in the work of Le Gray and his countrymen and that
they themselves sought – the strong massing of light and shadow and deep swathes
of Hugolian darkness – were thought a deficiency by English critics. The jurors of the
Great Exhibition described Le Gray's submissions as 'heavy and wanting in detail.'[6]
In Turner's pictures of trees, one feels the roughness of the bark, solidity of the
trunks and delicacy of the new shoots, just as one is struck by the sculptural quality
of the stone in his Whitby views or the textures of hay and wood and earth in his
farmyard scenes. His photographs are usually less about the evanescent effects of
light and atmosphere than about the physical character of the world we inhabit.

Turner's pictures were also without parallel across the Atlantic. America lacked
the institutions that helped shape French and British photography in the early
years – the academies, salons and watercolour societies, not to mention the royal and
imperial patronage. It also lacked the subject matter – the ruined abbeys and castles
of Yorkshire, the vestiges of Roman building in Provence, the Gothic cathedrals of
the Ile de France – and the accompanying sense of history that informed much of
early paper photography in Europe. And it lacked the landed men of leisure and

Fig. 4 Unknown Artist
California Gold Mining Town, c. 1860
Ambrotype
3⁵/₁₆ × 4⁷/₁₆ in (8.4 × 11.2 cm)
The Metropolitan Museum of Art, New York, The Rubel Collection;
Purchase, Lila Acheson Wallace Gift, 1997 (1997.382.51)

learning who could devote their energies to aesthetic pursuits.

The daguerreotype, which seemed to tell the truth, the whole truth and nothing but the truth, appealed to the American psyche more than the fuzzier, artier prints from paper negatives. The strength of this preference is seen in the fate of the Langenheim brothers' purchase of the American rights to Talbot's patent for making paper negatives and positives in 1848 – in other words, at the same moment as Turner was taking up the calotype in England. Anticipating the sale of sub-licences to fellow artists, they launched a nationwide promotion of the many advantages of paper prints… but failed to sell a single licence. Virtually the only artist to produce a body of landscape work in America using paper negatives was Victor Prevost (1820-81), working in New York City and areas farther up the Hudson River. But Prevost was French, brought the process with him, and to judge by the dearth of surviving prints met with little commercial success in his new home. Instead, the daguerreotype was king, and the portrait its domain.

The major American cities had luxurious daguerreotype portrait studios that equalled those of Paris and London in the splendour of their appointments and the quality of their products – Southworth and Hawes in Boston, Brady and Gurney in New York, the Langenheim brothers in Philadelphia. In addition to the major studios, thousands of itinerant practitioners, heirs to the limner tradition, travelled the countryside 'daguerreotyping' the residents of one town and moving on to the next, leaving inhabitants who would never have dreamt of having their portraits painted proudly clutching small, inexpensive, and relatively crude – but nonetheless miraculous – depictions of themselves to pass on to loved ones and to posterity.

Scattered daguerreotypes and ambrotypes of the 1840s and 1850s record the American landscape – notably views of mining towns after the 1848 California gold rush (fig. 4).[7] It was only in the 1860s, more than a decade after Turner's best work, that American photographers focused on the landscape as a sustained subject – first during the Civil War, when landscapes called to mind the deaths of young soldiers, not the poems of Wordsworth, and later during the military and geological surveys of the American West, when they made visible the political and commercial doctrine of Manifest Destiny. The best American landscape photographers, Timothy O'Sullivan (1840-82), Carleton Watkins (1825-1916), Eadweard Muybridge (1830-1904), among them, portrayed a continent vast and sublime, the antipode of Turner's intimate rural meditations (fig. 5). Lacking the history that Turner represented – the age-

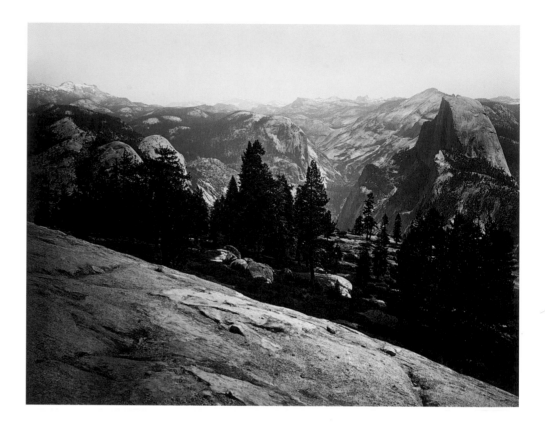

Fig. 5 Carleton E. Watkins
The Domes from the Sentinel Dome, Yosemite, 1865-6
Albumen silver print from glass negative
15⁷⁄₈ × 20¹⁄₂ in (40.3 × 52.1 cm)
The Metropolitan Museum of Art, New York; Purchase, Joseph
Pulitzer Bequest 1989 (1989.1084.1)

ing beech trees, the weathered barns, the mediaeval abbeys – American photographers instead represented time on a geologic scale.

Beneath the black cloth of his colossal camera, Turner saw on the ground glass a world that was familiar and to which he obviously felt deeply connected. Without formal training as an artist, Turner drew on the traditions of British landscape painting and watercolours, as Martin Barnes details elsewhere in this volume, but the content of his sometimes daring, sometimes lyrical images was surely rooted in his being. The power of Turner's photographs lies partially in their physical character – imposing scale, earthy texture and intense tonality – but the larger measure lies in their spiritual conviction, their expression of moral worth in tradition, nature and rural life and labour. The antidote such pictures provided to the ills of an increasingly industrial and commercial Victorian England remains potent – and welcome – in the twenty-first century.

Benjamin Brecknell Turner: A Biography

Benjamin Brecknell Turner:
A Biography

Mark Haworth-Booth

There is a relaxed portrait of B.B. Turner – probably a self-portrait from the 1850s – which shows him as a frank, open-faced, capable man (fig. 6). We might, judging from his handsome head and sturdy frame, place him as being 'of yeoman stock'. This is a man we would very likely trust with our friendship, and even some of our money. We would not be surprised to learn that he was successful in business and perhaps possessed other talents too. If that is what his portrait seems to say, most of the impression it gives is true.

Benjamin Brecknell Turner was born on 12 May 1815 in the family house at 31-32 The Haymarket, London.[1] The Haymarket, close to Piccadilly Circus, Leicester Square and Trafalgar Square, is – as every 'Monopoly' player knows – one of the capital's most favoured streets. It is replete, these days, with cinemas, theatres and shops – including Burberry's flagship store. However, when Turner was born, the Haymarket still maintained a little of the countrified aspect suggested by its name. Nos 31-32 served as the business premises of Brecknell & Turner, tallow-chandlers. The company was formed by Turner's father, Samuel, who went into partnership with his uncle-by-marriage, Benjamin Brecknell. The family lived above the company's factory and shop, where candles and saddle-soap were made and sold. One of Turner's descendants recalled a reference 'somewhere in Surtees' – the Victorian writer of popular huntin', shootin' and fishin' sketches – 'to a dining table shining with Brecknell Turners, which were the best quality candles'.[2] Turner's great-grand-daughter Muriel Arber recalled some of the company's products in a memoir she wrote in 1985:

I still have a yellow cardboard box which has printed on the lid: PURE HONEY SOAP MANU-FACTURED AND SOLD BY BRECKNELL, TURNER & SONS, Ltd., Skin Soap and Saddle Soap Manufacturers, 31 HAYMARKET, LONDON, S.W. There is a family story that a letter written in German arrived one morning and B.B.T. handed it to his wife to be translated. 'It is from the Austrian Cavalry, asking for saddle soap', she reported. 'But I don't make saddle soap,' said B.B.T. 'Then you will,' she said. So he did, and it was profitable.

The firm's tins of saddle-soap were familiar to equestrians well into the twentieth century. Turner was the second of a family of eight children, and the eldest son. He was the scion of a successful manufacturing dynasty. At 16 he was indentured as an apprentice to his father. He joined the Worshipful Company of Tallow Chandlers in

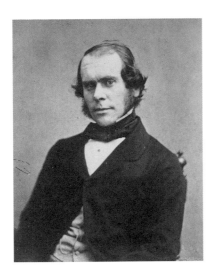

Fig. 6 B.B. Turner
Self-Portrait, 1850s
Albumen print from glass negative
3¾ × 3 in (9.6 × 7.5 cm)
Private collection, on loan to the V&A

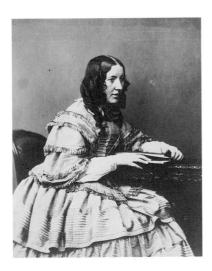

Fig. 7 B.B. Turner
Agnes Turner, 1850s
Albumen print from glass negative
8³/₁₆ × 6¹¹/₁₆ in (20.8 × 17 cm)
Private collection, London

1837 and became a Freeman of the City of London the following year. In 1836 the family had moved to Balham in south London. Turner rode in daily with his father. When Samuel Turner died in 1841 he left the business to his two elder sons, B.B. and Robert Samuel Turner. The latter took no active part in the business. He devoted his time and fortune to creating a great collection of books in his chambers in the Albany, in Piccadilly (arguably London's best address). As with some other notable bibliophiles, obsession eventually outstripped income. The fabulous library was auctioned. Its owner threw himself to his death from his Albany windows.[3]

The Balham house had been sold after Samuel Turner's death. His widow, and some of her sons, including Turner, returned to live in the Haymarket. Six years later, in 1847, Turner married Agnes Chamberlain, a member of the Worcester China family (fig. 7). She too joined the household of her mother-in-law and two or three brothers-in-law over the shop in the Haymarket. All Agnes's own eight children were born there. (Mrs Samuel Turner moved to a house of her own in 1856 to leave them more room.) A few glimpses of family life were recorded by Turner's great-granddaughter, Muriel Arber. They are worth preserving here because London plays no part in Turner's long photographic career – except for two extraordinary images.

The children were all christened at St Martin-in-the-Fields, as BBT himself had been, and they were proud of being true Cockneys, born within the sound of Bow bells. They played 'last across' in front of the horses drawing carts and cabs in the Haymarket; the eldest of the family, who had been given his father's name of Benjamin Brecknell, (my great-uncle Ben whom I remember well [she refers here to B.B. Turner's son, not B.B. himself]), on one occasion, while playing in Hyde Park, ran his hoop into the legs of the Duke of Wellington who swore at him roundly. On the night of the end of the Crimean War [in 1856], my grandmother and her sister Mary, as small children, were sent out in a cab with their nurse to see the celebrations, BBT and my great-grandmother having no idea of what the crowd would be like. It was terrifyingly dense, and my grandmother remembered a man putting his head into their cab for air – or so she believed.

Agnes Chamberlain (1828-87) belonged to another manufacturing dynasty. She was the daughter of Henry Chamberlain, who had for a time managed the London branch of the Chamberlain Worcester China business in New Bond Street. Henry Chamberlain gave up his share in the china factory in 1836, when it was reorganised

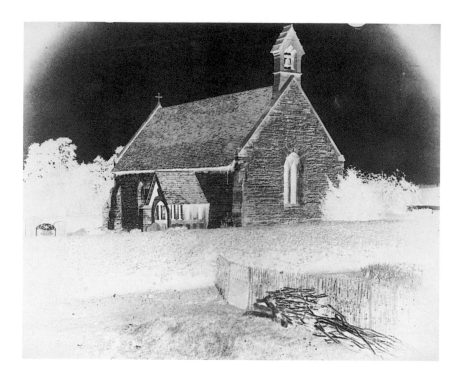

Fig. 8 B.B. Turner
Bredicot Church, c. 1850
Caloype negative
5 13/16 × 7 3/16 in (14.7 × 18.3 cm)
Private collection, on loan to the V&A

as Walter, Chamberlain and Lilly, to take up farming.[4] The following year he bought Bredicot Court, a seventeenth-century farmhouse with about 400 acres, some four miles from Worcester in the West of England. 'When he bought Bredicot,' Muriel Arber wrote, 'the land was in a very bad state and the house was almost ruinous, but it was gradually improved and became the beloved home of the family.' Turner and Agnes were married on 17 August 1847 in the church at Bredicot. It was the subject of one of his earliest photographs (fig. 8).[5]

According to the family history, 'BBT took up photography in 1849 with a licence from Fox Talbot'. Certainly Turner would have required a licence to practise paper photography. This would have been granted by its inventor, William Henry Fox Talbot, and would have cost one guinea 'for amusement only' (as opposed to professional purposes). How did Turner first become acquainted with the then still very new medium of photography? He was surrounded by daguerreotype portrait studios, which clustered in Regent Street to the north and the Strand to the east, but it was the paper process of Talbot that was the *plein-air*, landscape medium. Our best, if unreliable, witness is the writer of Turner's obituary, five decades later, in 1894. The

obituarist signed himself simply J.S., the initials of John Spiller (1833-1921).[6] Spiller was a chemist, photographer, sometime president of the Photographic Society of London (later the Royal Photographic Society) and man about the medium for 50 years. He is still remembered today for his experiments. One involved passing light through a bullock's eye set in a brass lens-mounting.[7] The obituary claimed that Turner was 'a friend of Fox Talbot' and contributed 'some of the illustrations to the now famous original publication known as *The Pencil of Nature*'. Spiller's credibility fades immediately when he adds that 'a copy of this work and the lens used in 1849 [sic] – one specially made by Andrew Ross – was exhibited in the Loan Collection of Scientific Apparatus, 1877, and afterwards presented to the South Kensington Museum'. *The Pencil of Nature* was published in instalments in 1844-6. However, there is a scattershot of near-truth in Spiller's recollections. Turner did give the South Kensington Museum a landscape lens made by Andrew Ross in 1876: this is currently on display in South Kensington, in the Photography Gallery at the Science Museum. The original museum records relating to the gift state that the lens was used to make photographs included in *The Pencil of Nature* – however, there is no evidence that Turner contributed to the publication or that he even knew Talbot. Turner did present a copy of *The Pencil of Nature* to the Photographic Society of London in 1859.[8] However, he possessed another set of the work, which he presumably retained in his own library until he died. It was later owned by the important photographic historian Erich Stenger and is now in the Agfa Historama at Leverkusen, Germany.[9] Thus, we can see why Spiller linked BBT with Talbot, even if he appears to have overstated the connection. He recorded that among Turner's most interested and respected friends were his cousin Professor George Fownes FRS, whom he consulted occasionally on chemistry, and Robert Murray, an instrument-maker of high repute, who made Turner's first camera. Other especial associates mentioned by Spiller were 'Mr Fox Talbot's coadjutors and original licensees, Messrs Henneman and Malone, of Regent Street'. Their premises were only a short stroll from Turner's own. What is more likely than that a licensee of Talbot's calotype process would avail himself of discussion with Talbot's own operatives?

Support for the family view that Turner began photographing in 1849 is found in a 'Photographic Scrap Book' he commenced in 1850.[10] This contains cuttings from magazines like *The Athenaeum*, which told of new technical improvements, gave canny tips on such matters as 'Glazing the Positive Proof' (to bring out detail and give

Fig. 9 William Henry Fox Talbot
The Haystack, 1844
Salted paper print from calotype negative
6⁷/₁₆ × 8¹/₄ in (16.3 × 21 cm)
Plate X from *The Pencil of Nature*, 1844
V&A, National Art Library

added 'finish' to a print) and news of a 'Photographic Club' (sometimes called the Calotype Club) which was said to be 'exciting much interest among artists: At the last meeting at Mr Fry's house – Sir Charles Eastlake, Mr Harding, Mr Roberts, Mr Mulready, Mr Lane, Mr Prescott Knight, Mr George Cruikshank, and several other artists and men of science were present'. This was an impressive group. Peter Wickens Fry was a lawyer and amateur photographer. Sir Charles Eastlake was a painter, director of the National Gallery and president of the Royal Academy and husband of the best early writer on photography, Elizabeth Eastlake. James Duffield Harding published popular teaching manuals on drawing technique. David Roberts RA was the pre-eminent topographical draughtsman of the monuments of the Holy Land, and William Mulready a master of genre painting. Mr Lane was perhaps the prolific lithographer Richard James Lane ARA, and John Prescott Knight RA was a painter and etcher of rustic subjects. George Cruikshank was the leading illustrator of the day. The gathering suggests how interesting the photographic medium was becoming to a variety of powerful constituencies and socially prominent individuals. In 1850 photography was poised to embark on one of the most inventive – and fashionable – decades in its history.

Turner might have known one or other of the members of the Photographic Club, but equally perhaps he was among the relatively few people who not only bought *The Pencil of Nature* but acted on it; after all, the publication was Talbot's brilliant advertisement for the practical and artistic possibilities of his astonishing new invention. Surely *The Pencil of Nature*'s small, subtle architectural and landscape views – and memorable, monumental hayricks and stables – provided Turner with the seed of his own adventure with photography (fig. 9). Whatever brought the new-fangled photographic medium to his close attention, part of the impetus to photograph came from a place very distant from London's artistic and scientific circles.

Turner and his wife and their growing family – the first four of their eight children were born in 1848, 1850, 1851 and 1853 – spent long summer holidays at Bredicot. It was remote. Agnes Chamberlain recalled the coach journey to London starting at seven in the evening, with changes of horses every ten miles, a stop in Oxford at one in the morning for half an hour's rest and refreshment, and arrival in central London at eight a.m. (It sounds more uncomfortable than an overnight flight from New York to London.) Agnes and the children went to Bredicot for two months each summer and Turner stayed for a month. Like Henry Chamberlain, he enjoyed shooting.

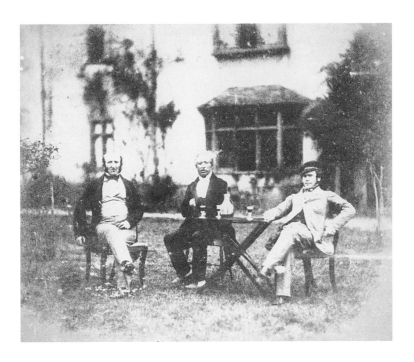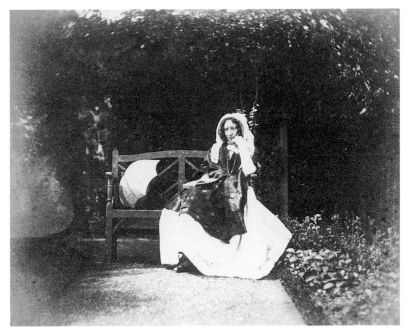

Fig. 10 B.B. Turner

The Wine Drinkers, Bredicot, c. 1850

(Left to right: Henry Chamberlain, unidentified man,

Benjamin Brecknell Turner)

Salted paper print from calotype negative

5 $^{11}/_{16}$ × 6 $^{11}/_{16}$ in (14.5 × 17 cm)

Private collection, London

Fig. 11 B.B. Turner

Agnes Turner seated with a Parasol, c. 1850

Salted paper print from calotype negative

6 × 7 $^{3}/_{16}$ in (15.2 × 18.3 cm)

Private collection, on loan to the V&A

However, in the late 1840s (about 1849 in his wife's recollection) he adopted the new summer recreation of photography. One of his early photographs is a view of the house at Bredicot: Turner (on the right), Henry Chamberlain and another man are shown seated at a table outside, drinking wine (fig. 10). The photograph, hesitant and imperfect as it is, still evokes the thrill of an early semi-successful effort. Turner photographed his wife with similarly haunting semi-success, *plein-air* at Bredicot, around the same time (fig. 11).

Bredicot was really only the house itself, plus a 'rough farmhouse', as Agnes Turner called it, named Mantells (seen in Turner's grand photograph in pl. 6), 'and half a dozen miserable cottages'. The railway, which was cut through in about 1840, ran only 100 yards (91 m) behind the house and church, but Turner never photographed it. He did not altogether shun contemporary subjects in these early photographs. There are several studies of the main street and shops of an unidentified small town as well as Worcester Cathedral set in a complicated townscape.[11] These were made with a modestly scaled camera, taking negatives of about 7 1/2 × 5 1/2 inches (19 × 14 cm).

For the Turner family Bredicot was what the poet W.H. Auden liked to call 'the

good place'. This is clear from a typescript based on the memoirs of Agnes Turner and other family members:

Bredicot was an exceptional village in some ways. There was no public house or beer shop. A man must walk more than a mile to find some liquor. The allowance of beer to the farm labourers was very large; in harvest time as much as five or six quarts per diem; but none of it went home except inside them!

The daughters and their husbands spent summer holidays at Bredicot (Agnes and Helen) in turns, and as they both had large families the children all had a wonderful time together. They were allowed to run wild there, which was a great treat to them after their restricted life at home in more conventional surroundings. They made houses in the wide area of nut bushes that surrounded one side of the garden, picked apples, nuts and blackberries, hunted for eggs (for the hens laid anywhere)… They watched the cider being made, the harvest, the threshing, rode in the wagons, played with the innumerable cats, kittens and dogs in the barns and out-houses, saw the cows milked, and drove to Worcester on Saturdays with their grandmother to do the shopping, and took part in all the country delights…

Benjamin Turner, when staying there, spent a good deal of time taking photographs, his camera being a huge square box, about 30 inches square, which was lifted onto a little platform with wheels and pulled along. The legs, strong and heavy, folded in half and had to be carried. There was also a little folding tent, with apparatus for changing plates. Developing was apparently done on the spot. Of course the untidy farm furnished endless subjects for photography.[12]

So suddenly Turner had a huge camera. In fact we can see it in a photograph of the leading British photographers of the 1850s (fig. 12). The stovepipe-hatted Turner is standing proudly at the right-hand side of the group beside his giant camera. When and why did he acquire this formidable instrument?

The Great Exhibition of 1851 was crucial for photography – and this was recognised straight away. For the first time anywhere in the world many fine photographs were brought together and placed on display. Photography, formerly the preserve of commercial daguerreotype portrait studios on the one hand and experimental scientists and artists on the other, suddenly achieved what we would now call critical mass. Over 700 photographs from six countries were shown.

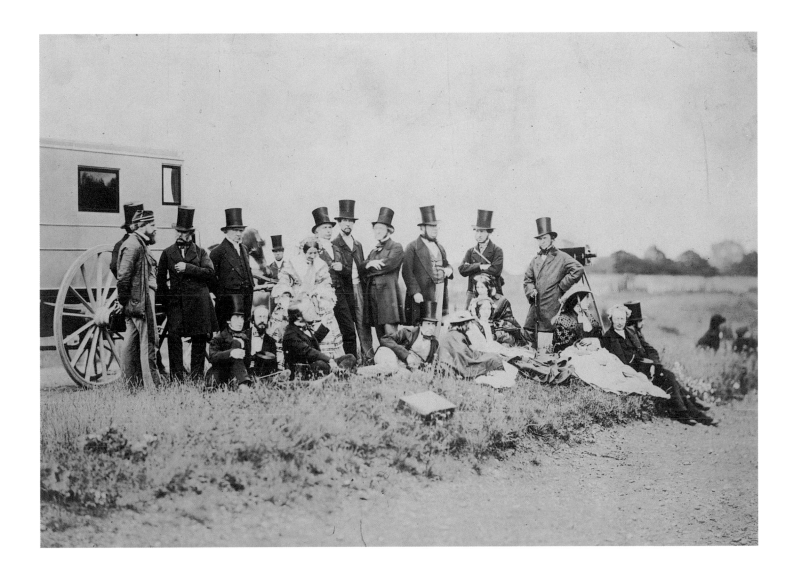

Fig. 12 Anonymous (British, nineteenth century)
Members of the Photographic Club Meeting at Hampton
Court, 1856
Albumen print
9 1/2 × 13 1/4 in (24.1 × 33.7 cm)
The Royal Photographic Society, Bath, England

The lions' share of these were from Britain, France and the United States. The international jury which assessed photography praised, above their British counterparts, American daguerreotypes and French calotypes. (According to family tradition Turner actually showed his photographs at the Great Exhibition. However, his name does not appear in the catalogues and – although some items were added during the course of the exhibition – neither is he mentioned in the reports and reviews published at the time.) Although Turner might have admired the delicate rural calotypes of Samuel Buckle, shown in the Fine Art section, Talbot's process had

progressed furthest in the hands of French artists. No one was more influential than Gustave Le Gray, who made a crucial adaptation to the calotype. He used his waxed paper process (published in 1851) to create large, refined views of the monuments of France, but also the glades of the Fontainebleau Forest. His photographs did two things simultaneously: jumped in scale from the writing-paper size of calotypes to something like that of the exhibition watercolour, and embraced the stylistic concerns and subjects of contemporary art. These woodland scenes are 'Barbizon School' photographs, close kindred to the paintings and drawings of Théodore Rousseau, Jean-François Millet and their followers. The larger scale and greater ambition seen in the French works were very evident when set against the smaller and sometimes less adventurous efforts by British practitioners, who were still subject (unlike the French) to Talbot's patents.

Turner celebrated the possibilities opened up by the Great Exhibition with a highly symbolic photographic act. In March 1852, when the last of the six million visitors had departed and nearly all the thousands of exhibits had been removed – but before the building had been dismantled (to be rebuilt in Sydenham in south London) – Turner photographed the interior of the Crystal Palace (pls 1 and 2) His giant new camera took negatives of approximately 10 1/2 × 15 1/2 inches (27 × 39 cm) in size. He positioned it near the Great Entrance, looking north into the transept. This was the lightest part of the building and its focal point. Here, on a dais beside a cut-glass Crystal Fountain, speeches had been given and banquets consumed. Palm trees had rustled in the shadow of the elm. The palms had gone, but the elm put forth new leaves. It stood there, enclosed by Sir Joseph Paxton's revolutionary design in iron and glass, beside the skeleton of the Crystal Fountain. Building, light and tree combine to become a symbol of the strange properties of the medium of photography, a human invention that harnessed the power of the sun to make pictures of unprecedented naturalistic accuracy. Turner made a second picture, showing the swooping lines of the roof trusses. Other photographers worked in the Crystal Palace; none matched this image of the brilliant tensile geometry of its structure. When he came to assemble his album, *Photographic Views from Nature*, of 60 photographs from the years 1852, 1853 and 1854, Turner placed the two Crystal Palace views first, like an epiphany.

Turner began to photograph with new ambition in 1852, and commenced his long and distinguished career as an exhibitor later in December of the same year. Six of his

photographs were shown in the world's first purely photographic exhibition. *Recent Specimens of Photography* appeared at the Society of Arts in London, and subsequently toured to centres in England and Scotland. Among the six photographs Turner exhibited was another highly symbolic work. He gave it the title *A Photographic Truth* (pl. 27). The parish church at Hawkhurst in Kent appears not once but twice – in reality and in reflection. Surely the great photographer Roger Fenton was thinking of this picture when he wrote the catalogue essay for the Society of Arts exhibition. Here he characterises the new English photography and the subjects it excelled at interpreting:

the peaceful village; the unassuming church, among its tombstones and trees; the gnarled oak, standing alone in the forest; intricate mazes of tangled wood…. the still lake, so still that you must drop a stone into its surface before you can tell which is the real village on its margin, and which the reflection.[13]

While other photographs of the time – French and English – play wittily with reflection, none treats the subject quite so inescapably and abstractly as Turner. No other photograph of the time emphasises the philosophical possibilities of the subject through such a bold title. We must suppose that Turner wished us to contemplate the way in which photography reflected phenomena with the naturalness and truth of a sheet of water; this naturalness, caused by the laws of chemistry and optics, was a large part of the attractiveness of photography in its experimental period. The idea chimes readily with late twentieth-century ideas about the self-reflexiveness of creative media. One writer has argued that the presence of mirrors or doubling in early photographs demonstrates that photographers were deliberately emphasising the creative potential of the medium. It is an attractive speculation but surely no more than that.[14] There is another facet to this image: Collingwood near Hawkhurst was the home of Sir John Herschel FRS, the friend of Talbot who suggested to him (in a letter dated 28 February 1839) the name by which we have come to know the medium. Herschel argued for 'photography' (Greek: *phos* – light and *graphein* – to write), as opposed to Talbot's preferred 'photogenic drawing' (Greek: *genesis* – source). Part of the attraction of the word photography is that it allows a broader range of adaptations, like – for example – the adjective 'photographic'.[15] However, no evidence appears to survive which links Turner and

Herschel. We should also note that a contemporary of Turner's, Robert Hunt, had this to say of his picture: 'The "Photographic Truth" is not nature's truth, the watery mirror reflecting solar light never gave to the eye such an image'. By this he meant that 'the lights upon the trunks of the trees, and those spread over the various surfaces of *green* sward, *brown* paths, and *blue* water, are not such as we see in nature'.[16] However natural photographs seemed, they were still abstractions, formed by choices. These choices dominated the discussions among photographers in the 1850s. Photographers and critics discussed negative material (paper negative or glass negative were just the beginning of a series of options), camera and lens, printing papers (salted paper or albumen, English or French, if English then Whatman's or R. Turner's), toning baths and final finish (the tone of prints might be subtly enhanced by glazing, waxing and even ironing).

In order to facilitate the exchange of such information, the Photographic Society of London was formed in 1853. Turner was a founding-member and later served as a vice president. In 1858 he gave the society's embryonic collection four of the photographs he had shown in the Society of Arts exhibition of 1852 as well as the copy of *The Pencil of Nature*. He also showed his work in the society's annual exhibitions, which began in 1854, as well as in exhibitions in Norwich, Manchester (*The Art Treasures of England* exhibition of 1857), Edinburgh and Glasgow. He exhibited in the international exhibitions held in Paris in 1855 (when he received a bronze medal) and in South Kensington in 1862. Whereas his contemporaries moved on from calotype photography (with its paper negative unwaxed before exposure), switching to Le Gray's waxed paper process or to glass negatives, Turner remained true to what he often called the Talbotype. The fibres in paper negatives gave a relative roughness of texture to his photographs, which suited their characteristically rustic or rugged subjects. When he experimented briefly with wet collodion on glass negatives in 1856, he was rebuked by critics and commended to return to his forte – which he did. The evidence of his foray into glass is a pair of images he exhibited at the Norwich Photographic Society in 1856: *Bonchurch, Isle of Wight* and *Our Village*. The Bonchurch photograph has the smooth textures and wiry outlines typical of prints from glass. The masonry of the church lacks the impressive tactile qualities Turner achieved with paper.[17] Unlike his paper negatives, many of which have survived, Turner's glass negatives are presumed lost. We can only conjecture the subject of the photograph he exhibited as *Our Village*. Turner's large landscapes on paper negatives customarily

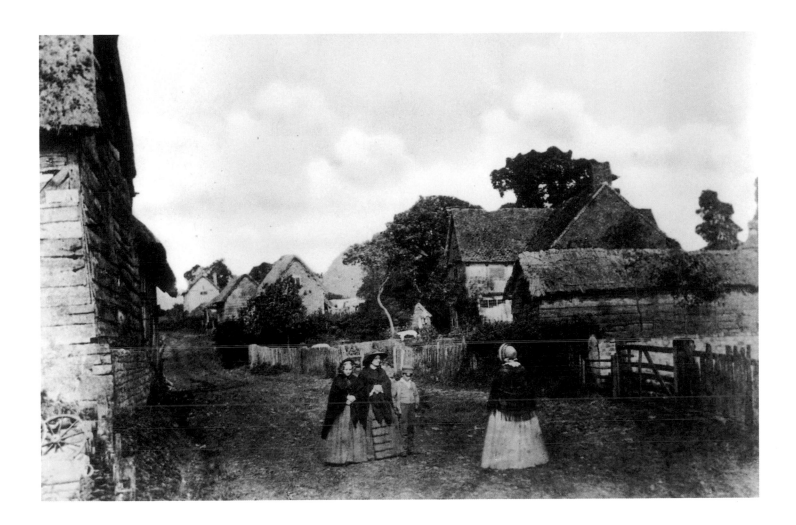

Fig. 13 B.B. Turner,
Our Village [?] [Agnes Chamberlain and family in the lane at
Bredicot], c. 1856
Modern copy print from albumen print
Original dimensions unknown
Copy print V&A, original formerly collection of Muriel Arber,
Cambridge

demanded 30-minute exposures.[18] *Our Village* may be the title of a photograph that he
could only have attempted using the speed offered by wet collodion on glass: perhaps
it is an unusual photograph Turner made in the lane at Bredicot (fig. 13). His wife
stands in the lane, her back turned, looking towards her sisters Mary and Helen and
her son Benjamin Brecknell Turner Jr. The figures could not have held their poses
long enough for an exposure on a large paper negative. Turner used collodion on
glass because he had to. If this is the photograph exhibited as *Our Village*, no doubt
Turner was invoking the title of the Victorian classic of the same name, with its
delighted close observations of country life, published by Mary Russell Mitford (1787-
1855). Her sketches, first published in the *Lady's Magazine*, appeared in five volumes

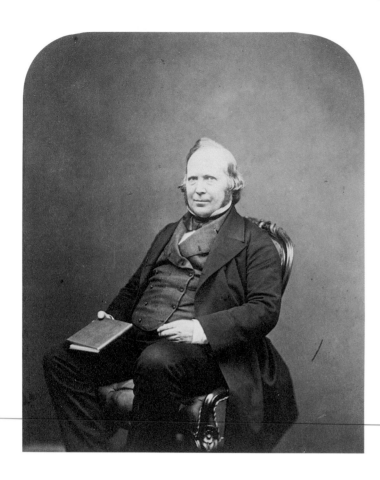

Fig. 14 B.B. Turner
David Bogue, Bookseller in Haymarket, c. 1855
Albumen print from glass negative
8⁷⁄₁₆ × 6⁷⁄₈ in (21.4 × 17.4 cm)
Private collection, London

(1824-32). *Our Village* opens with a sentiment we find echoed in Turner's photographs of Bredicot and other rural places:

Of all situations for a constant residence, that which appears to me most delightful is a little village far in the country; a small neighbourhood, not of fine mansions finely peopled, but of cottages and cottage-like houses, 'messuages [a house with outbuildings and adjacent land] or tenements', as a friend of mine calls such ignoble and nondescript dwellings, with inhabitants whose faces are as familiar to us as the flowers in our garden…

If our identification of it is right, *Our Village* is the occasion on which Turner symbolically peopled the empty Bredicot lane for the first and last time. Perhaps he also intended it as a tribute to Mary Russell Mitford, who died the previous year. We can see that he took pains over this photograph; it is not a family snapshot. Turner blacked-out the sky on the negative – as can be seen from the unconvincing shapes of the silhouetted trees – and he inserted fluffy clouds (created by brushing iodide, cyanide of potassium or Indian ink on the negative).

Turner also made studio portraits on glass negatives. According to John Spiller, he built himself 'a studio and dark room for experimental photography and portraiture early in the year 1855'. Turner's 'glass-house' was above his Haymarket premises. He made many portraits here in the 1850s although he seems never to have exhibited them. His subjects were members of his business and household, like the servant Lepping, and his family, including his namesake B.B. Turner Jr – shown attentively reading one of the first annual volumes of the *Photographic Journal*. He photographed business associates like the poulterer Mr Eagle and the Haymarket bookseller David Bogue (fig. 14). He also made a fine portrait of the painter and photographer Mark Anthony (1817-86) who was a member of the Photographic Exchange Club (fig.15). Turner served as treasurer and honorary secretary to the club. He masterminded a handsome volume of photographs titled the *Photographic Album for the Year 1857*. This was intended for private distribution among the club's members, although a few extra copies were available from Turner at the cost of an honorary member's sub-scription of 10 guineas.[19] A copy was sent to Queen Victoria, who was (with Prince Albert), a notable collector of photographs at this time. According to family tradi-tion, Turner's photograph *Scotch Firs* was admired by Prince Albert and presented to him by Turner: neither this nor the Photographic Exchange Club Album appear to

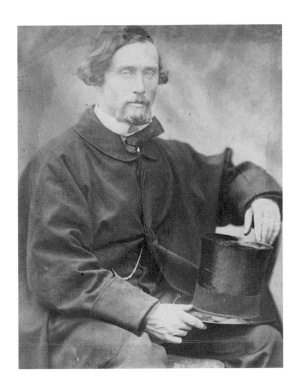

Fig. 15 B.B. Turner
Mark Anthony, Painter and Photographer, c. 1855
Albumen print from glass negative
2 3/4 × 4 11/16 in (7 × 11.9 cm)
Private collection, London

have survived in the royal collections.[20] The club also produced the *Photographic Album for the Year 1855*. Turner contributed a view of Bredicot Court (pl. 6), accompanied by a quotation from 'Geoffrey Crayon', the pseudonym of the American writer Washington Irving: 'England does not abound in grand and sublime prospects, but rather in little home-scenes of rural repose and sheltered quiet. Every antique farmhouse and moss-grown cottage is a picture'.[21] Crayon's text continued on lines that may also have been sympathetic to Turner: 'The great charm, however, of English scenery is the moral feeling that seems to pervade it. It is associated in the mind with ideas of order, of quiet, of sober, well-established principles, of hoary usage and reverend custom'. Perhaps such values were particularly attractive in the volatile and intensely innovative years of the 1850s.

Turner was, according to John Spiller, chiefly responsible for producing an album of portraits titled *Rules of the Photographic Society Club*. Turner himself appears in the album in a different guise from his early self-portrait – formally, even stiffly, posed and attired in a dapper style which the glass negative captured in exhaustive detail.

During the 1850s and into the 1860s Turner remained true to calotype for his landscapes. Writers praised him for it:

Turner's 'calotype' old oaks, &c., equal anything of the same size that we meet with, whether glass or [waxed] paper';[22] …his old oaks and cottages are far bolder than anything on collodion; broad shadows, which give a massive look to the trunks and architecture, and a stereoscopic effect which few, very few, collodion pictures have. The difference seems to me to be, that the collodion subjects are intended to be kept in a portfolio, and the large paper productions are far more fit to be framed and hung on the walls.[23]

Turner's works appeared on many exhibition walls in the first 10 years of photographic exhibitions (1852-62). They were on sale at many of these exhibitions. Records of the sales of photographic prints at this period are almost non-existent, but papers relating to one exhibition in which he showed have fortunately survived. This was the third annual exhibition of the Photographic Society of Scotland, which opened in December 1858. It was held in the stylish, purpose-built, top-lit Edinburgh art gallery of David Ramsay Hay. The photographs were hung in gilt frames on claret-coloured walls. The exhibition records show that Turner received orders from visitors to the exhibition for 12 photographs.[24] At this time his photographs were

priced at 7. 6d. each.[25] It was still the era in which positives were generally sun-printed rather than chemically developed and Turner wrote to the organizers 'that they take a long time to print'. He added: 'I am not a *Professional* Phot.r – only an Amateur – and do not find it convenient to *print* my own pictures, especially this time of year – I have written to the printer (Mr Spencer) who did those in your exhibition for me to get those ordered ready as soon as possible and directly I receive them from him I will forward them to you'.[26] The Turner photographs in his own album are different in many ways from some of the surviving prints mounted on card. The album prints are warmer in colour and relatively matte in surface. The card-mounted prints are cooler, greyer and more glossy. The former seem hand made, the latter almost mechanical. A similar difference appears in 1850s Roger Fenton prints compared to those printed from his negatives posthumously by Francis Frith & Co. early in the following decade, which are harder, brighter and more machine like. However, although we may conjecture that Turner printed his album photographs himself, we cannot be sure; he may never have printed his own photographs. We can at least be certain that there was sufficient demand for his photographs for him to place print-orders in the hands of a professional. It is likely that Turner's photographs were also sold through the leading London photographic suppliers, Murray and Heath.[27]

Turner was highly productive and visible during the 1850s. His photographic campaigns took him to many parts of England and to Holland in 1857. He seems to have relished the company of his fellow photographers, joining them on expeditions, serving the Photographic Society and its associated club, and giving valuable photographica to the society and to the South Kensington Museum. With his distinguished colleagues Roger Fenton and Henry White (1819-1903), he also donated 50 of his prints to the society's members in 1860.[28] Like Fenton, John Dillwyn Llewelyn (1810-82), Oscar Rejlander (1813-75), Horatio Ross (1801-86) and other photographers, Turner also joined the temporary army of 'Volunteers', which was supposed to repulse the French during the diplomatic crisis of 1859-60.[29] We find him at a glittering Photographic Soirée held at the Mansion House, residence of the Lord Mayor of London, on 18 April 1859. The Egyptian Hall was filled with displays of fine photographs, including Turner's own, as well as 'philosophical instruments'. There were dissolving stereoscopic views, for example, an elegantly designed model showing the application of electromagnetic power, 'music at short intervals and an

abundant supply of delicacies… The hall was most brilliantly lighted, and the animation imparted to the general aspect of the company by the presence of ladies in gay dresses, which owing to the present fashion, were seen to great advantage, made it one of the prettiest sights imaginable.'[30]

In 1861 Turner created a second album: *Bredicot and Crowle, Worcestershire, Photographed by Benjamin B. Turner, 1850-61*. It contained 36 photographs, measuring about 11 1/4 × 15 1/2 inches (29 × 39 cm) and smaller. This oblong album in half morocco was sold at a famous auction of photographic material held at Swann's Auction Galleries in New York on 14 February 1952. It fetched only a few dollars and its whereabouts are now unknown. In the 50 years since 1952, photographs by Turner and his contemporaries have changed their status from the almost worthless to the nearly priceless. Turner showed some of his Crowle Court photographs at the International Exhibition in South Kensington in 1862, together with Bredicot pictures. The International Exhibition was a resounding failure for British photography, mainly because of the way the material was displayed – in an inaccessible gallery in blistering heat which caused prints to fade and vessels of collodion to explode.[31] Perhaps because of this, some major talents – including Roger Fenton and William Lake Price (1810-95) – left the medium in 1862. Turner seems to have retreated for a few years from the public exhibition of his photographs. He and his family left central London in 1864 for a house at Tulse Hill in the southern suburbs. His wife's diary recorded holidays in Cromer in 1871 and 1872, Charmouth in 1874, Brittany in 1875, Barmouth in 1876 and Newquay in 1877.[32] He may well have photographed on all these holidays. His wife specifically mentions him photographing at Chideock, near Charmouth, in south-western England in 1874 and during the Newquay holiday of 1877.[33] He showed two recent prints at the Photographic Society's annual exhibition in 1875. They were enlargements in the carbon process, a permanent pigment process which became generally available from around 1865, from his calotype negatives of the early 1850s, including *Scotch Firs* (pl. 24).[34] He showed two more carbon enlargements at the annual exhibition of 1881, but this time they were from the newly introduced gelatine dry-plate negatives.[35] Some of these survive and show that he had successfully translated the quality of his early pictures into the new technique.[36] His late work follows the lines of his great period in the 1850s: it is large, striking and meticulous, delighting in landscapes of human intervention and husbandry, featuring sturdy rural bridges, vigorous trees and handsome mills (fig. 16). After that he

Fig. 16 B.B. Turner
Willows Beside a Stream, c. 1880
Carbon print
13⅝ in × 17⅛ in (34.6 × 43.5 cm)
V&A; Mrs M. Orton gift, 2000
E. 1207-2000

seems to have settled into retirement from the medium and his business. Agnes Turner died in 1887 and Turner himself in 1894.

Turner's posthumous career began early. The Royal Photographic Society organised a gigantic exhibition of photography at the Crystal Palace in 1898. H. Fownes Turner, the photographer's son, lent eight works. With a pleasing circularity the exhibits included 'A Photographic Truth' and 'Interior of the 1851 Exhibition'.

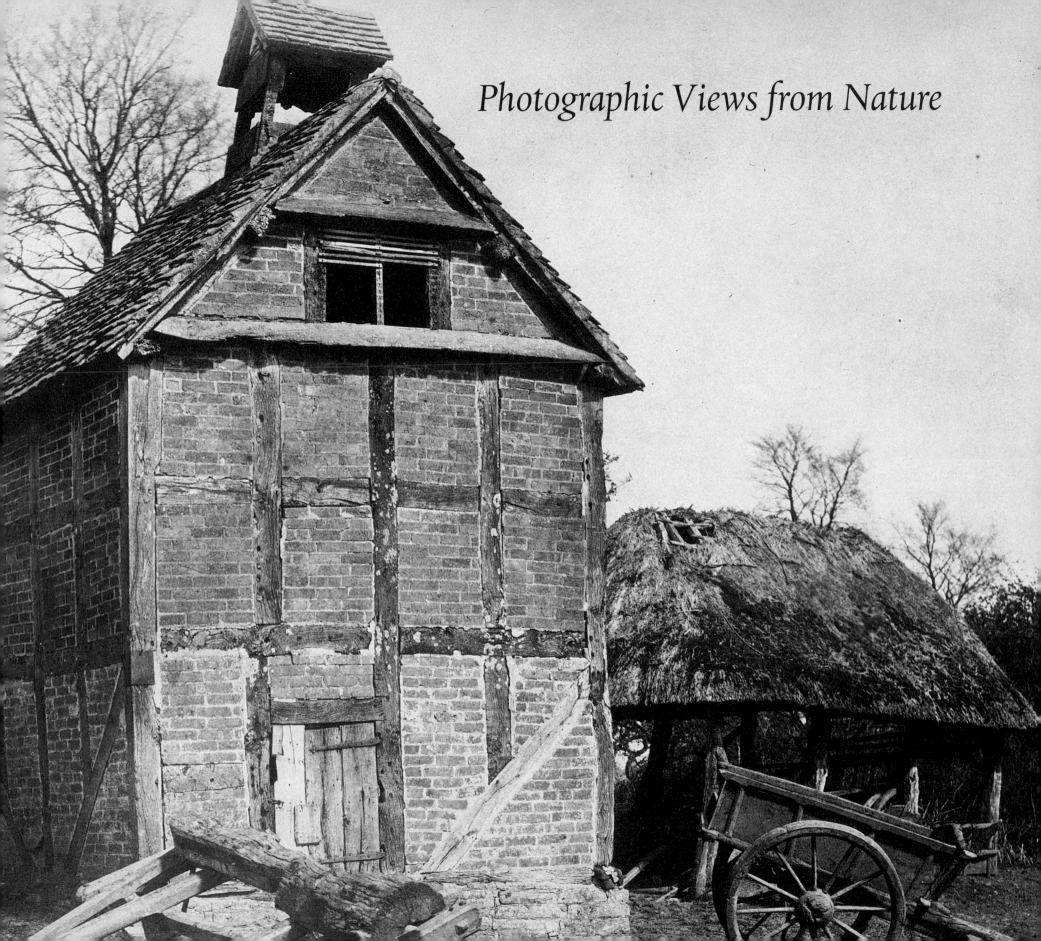

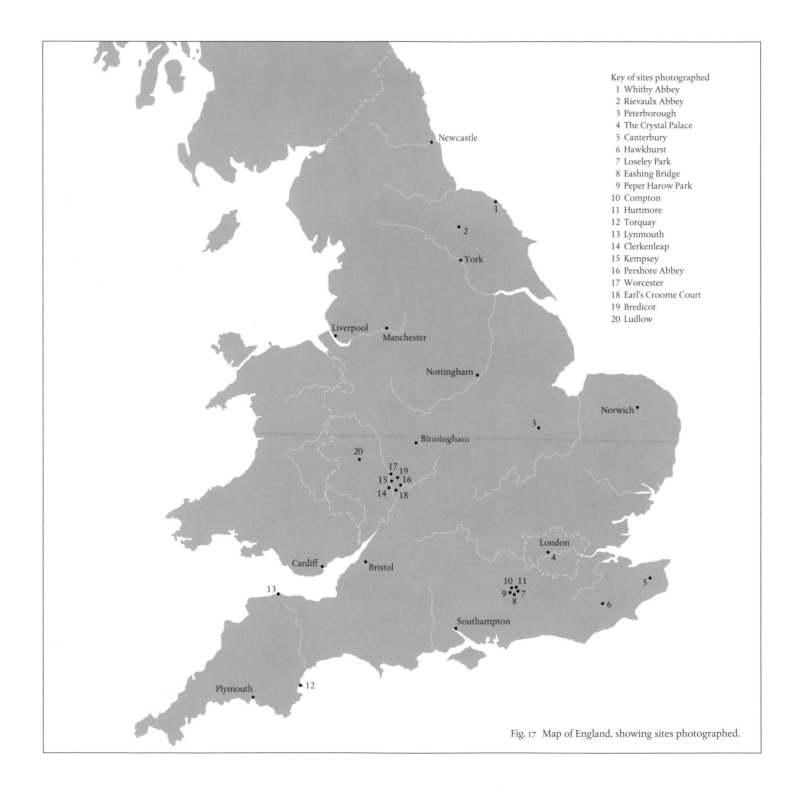

Key of sites photographed
1 Whitby Abbey
2 Rievaulx Abbey
3 Peterborough
4 The Crystal Palace
5 Canterbury
6 Hawkhurst
7 Loseley Park
8 Eashing Bridge
9 Peper Harow Park
10 Compton
11 Hurtmore
12 Torquay
13 Lynmouth
14 Clerkenleap
15 Kempsey
16 Pershore Abbey
17 Worcester
18 Earl's Croome Court
19 Bredicot
20 Ludlow

Newcastle

1
2
York

Liverpool
Manchester

Nottingham

Norwich

3

Birmingham

20
17 19
15 16
14 18

London
4

Cardiff
Bristol

10 11
9 7
8

5

6

13

Southampton

Plymouth
12

Fig. 17 Map of England, showing sites photographed.

Photographic Views from Nature

Martin Barnes

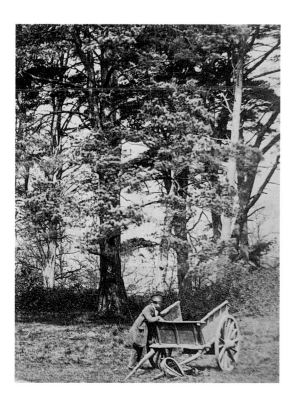

Fig. 18 Charles Thurston Thompson
Detail from *Scotch Firs, Albany Warren, Surrey,* c. 1860
Albumen print from glass negative
9³/₁₆ × 11¼ in (23.4 × 28.5 cm)
V&A guard book, 366

Natural beginnings

Benjamin Brecknell Turner normally chose a bright clear day to set out on a photographic excursion in the English countryside. He does not appear to have minded if it was summer or winter as long as the light was good enough. If anything, he seems to have preferred crisp winter days when the intricate pattern of branches and the rooflines of dramatic ruins stood sharply outlined against the sky. He manoeuvred his heavy photographic equipment along country roads to secluded places in a horse-drawn cart.[1] It probably looked something like the one used by Charles Thurston Thompson, the South Kensington Museum's professional photographer, on a trip in 1860 to make photographic tree studies for art students to copy (fig. 18). By the 1860s photography had become a commercial enterprise and Turner already had 10 years' experience pioneering such subjects as works of art in their own right. He was drawn to it not to make a living but as one of the first generation of passionate and talented amateurs excited by the new medium in the late 1840s and early 1850s. The exuberance of Turner's first years of photography shines through his pictures to this day.

Photography as we know it was barely 10 years old when Turner took it up in 1849 at the age of 34. Perhaps the novelty of the new art, and participating in the exhibitions and clubs devoted to its development, provided a welcome escape from the pattern of his life in trade until then. Whatever his reasons for embracing photography he took it up with gusto. He was spurred to travel the country, perhaps journeying most of the longer distances on the growing rail network, making pictures in locations as far afield from his native London as Lynmouth to the west in Devon and Whitby to the north in Yorkshire. From 1852 to 1854, a period of intense creativity, Turner produced a wide range of highly accomplished photographic views and compiled 60 of those he no doubt considered his best in an album. He titled it *Photographic Views from Nature*, had it bound in green pigskin and stamped with decorative borders and the title in gold (fig. 19).

As far as is known this album is unique. There is nothing about the type of binding, the printed title or contents page (figs 19-21) which suggests that a press was set up commercially to produce further copies.[2] The photographs it contained were all the same size as those Turner exhibited, on average about 10 1/2 × 15 1/2 inches (27 × 39 cm). These positive prints were contact printed from paper negatives of the same

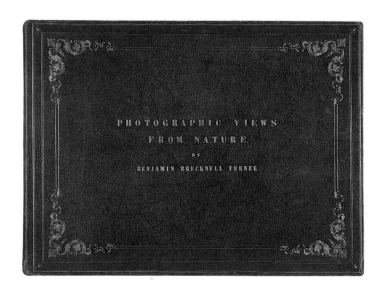

Fig. 19 Album cover for *Photographic Views from Nature by Benjamin Brecknell Turner Taken in 1852, 1853 and 1854 On Paper by Mr. Fox Talbot's Process*, c. 1854-5
Gilt and tooled leather
17 1/2 × 23 5/8 × 1 3/4 in (44. 5 × 60 × 4. 4 cm) V&A

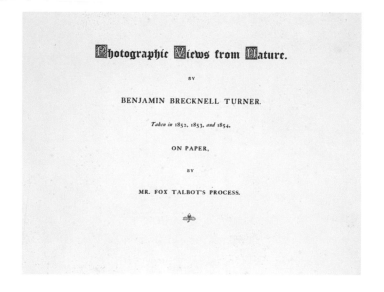

Fig. 20 Title page for *Photographic Views from Nature*
16 3/4 × 20 5/8 in (42.2 × 55.3 cm) V&A

size. Turner composed his picture in the camera and usually printed the whole negative. In some instances the prints were trimmed to slightly smaller sizes to improve the composition or hide the occasional fault or damage at the edges of the negative.[3] On the title page Turner proclaimed his allegiance to the Talbotype or calotype, 'Mr. Fox Talbot's process'.

The album might have been made as a kind of sample book showing what Turner could do. It would have been a convenient method of storing and presenting his photographs for his personal pleasure and to show colleagues or potential exhibitors. Perhaps he put it together as a way of presenting his work to the exhibition organisers of the 1855 Paris Exposition Universelle, which was the French follow-up to London's 1851 Great Exhibition. Whatever the intended purpose of the album, the most remarkable feature about it is the visual sophistication of the photographs it contains. Turner exhibited a sense of ease with different compositional structures and consistently found satisfying visual solutions to the pictorial challenges of diverse subject matter. He was able to make powerfully arranged sequences of pictures. He worked with the peculiarities of the medium – such as its monochrome palette, its ability to record detail and to zoom in and flatten out perspective – and turned them to his advantage. Many of his best images stand up to deeper analysis in terms of their symbolic content.

All this seems unusual for a practitioner with no documented formal artistic training and relatively few years' experience with a largely untried new invention. So how did Turner form his aesthetic sense? Certainly he was familiar with some of the earliest examples of paper photography at first hand for he owned a copy of Talbot's pioneering publication, *The Pencil of Nature* (1844-6).[4] In his introductory text to the publication Talbot stated his hope for the development of the medium by artists in the future, especially home-grown practitioners. He also advocated a particular kind of aesthetic sensibility, derived from Dutch painting:

The chief object of the present work is to place on record some of the early beginnings of a new art, before the period, which we trust is approaching, of its being brought to maturity by British talent... A painter's eye will often be arrested where ordinary people see nothing remarkable. A casual gleam of sunshine, or a shadow thrown across his path, a time-withered oak, or a moss-covered stone may awaken a train of thoughts and feelings, and picturesque imaginings.[5]

CONTENTS.

1. CRYSTAL Palace, Hyde Park, 1852, Tranfept.
2. Cryftal Palace, Hyde Park, 1852, Nave.
3. Lynmouth, North Devon.
4. Lyndale, North Devon.
5. Gateway, Cathedral Yard, Peterborough.
6. Worcefter Cathedral, from acrofs the Severn.
7. The Edgar Tower, Worcefter.
8. Abbey Church, Perfhore, Worcefterfhire.
9. Old Doorway, Perfhore Abbey.
10. Windmill, Kempfey, Worcefterfhire.
11. Earl's Croome Court, Worcefterfhire.
12. Earl's Croome Church, Worcefterfhire.
13. Hedgerow Trees, Clerkenleap, Worcefterfhire.
14. Crowle Court, Worcefterfhire.
15. Hedgerow Trees, Clerkenleap, Worcefterfhire.
16. Bredicot, Worcefterfhire.
17. Bredicot, Worcefterfhire.
18. Bredicot, Worcefterfhire.
19. Bredicot, Worcefterfhire.
20. Bredicot, Worcefterfhire.
21. Cottage, Bredicot Common, Worcefterfhire.
22. Bredicot Court, Worcefterfhire.
23. Foldyard, Bredicot Court, Worcefterfhire.
24. Bredicot Church, Worcefterfhire.
25. Ludlow.
26. Ludlow Caftle, from the Garden.
27. Ludlow Caftle, from the Tiltyard.
28. Ludlow Caftle, from the Tiltyard.
29. Ludlow Caftle, Caufeway and Entrance.
30. Ludlow Caftle, Doorway of Round Church.
31. Ludlow Caftle, Banquetting Hall.
32. Eafhing Bridge, Surrey.
33. At Compton, Surrey.
34. At Compton, Surrey.
35. Hurtmore Lane, Surrey.
36. Hurtmore Lane, Surrey.
37. Pepperharrow Park, Surrey.
38. Lofely Houfe, Surrey.
39. Entrance Gateway, Lofely Houfe.
40. Lime Trees, Lofely Park.
41. Caufeway, Head of the Lake, Lofely Park.
42. Caufeway, Head of the Lake, Lofely Park.
43. Alfred Hall, Arundel Caftle, Suffex.
44. North Side of Quadrangle, Arundel Caftle.
45. Hurftmonceaux Caftle, Suffex.
46. Rivaulx Abbey, Yorkfhire.
47. Whitby Abbey, Yorkfhire, from the North Eaft.
48. Whitby Abbey, Yorkfhire, from the South.
49. Whitby Abbey, Yorkfhire, Interior View.
50. Whitby Abbey, Yorkfhire, Site of Central Tower.
51. Whitby Abbey, Yorkfhire, North Tranfept.
52. Whitby Abbey, Yorkfhire, North Tranfept.
53. Hawkhurft Church, Kent.
54. Hawkhurft Church, Kent.
55. Near Hawkhurft Church, Kent.
56. Elm Trees, Elfords, Hawkhurft.
57. Farm Yard, Elfords, Hawkhurft.
58. The Willowfway, Elfords, Hawkhurft.
59. Scotch Firs, Hawkhurft.
60. The Church Oak, Hawkhurft.

Fig. 21 Contents page for *Photographic Views from Nature*
16 ¾ × 20 ⅝ in (42.2 × 55.3 cm)
V&A

Turner proved himself to be one of the most able British talents to rise to Talbot's challenge and adopt with skill the prescribed visual codes for imaginative or emotional effect. He had Talbot's publication and writings as a guide and so was aware of the possibilities and unique visual character of the medium. Turner's choice of images and title for his own compilation of prints *Photographic Views from Nature* reads like an homage, updated for the 1850s, to Talbot's *The Pencil of Nature* – but with a subtle difference. The idea that Turner's views are *from* rather than *of* Nature is

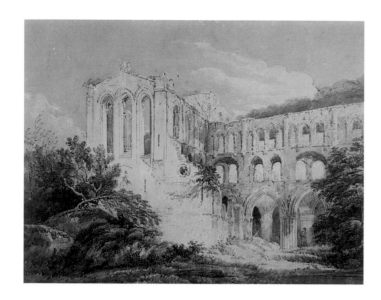

Fig. 22 Thomas Girtin
Rievaulx Abbey, Yorkshire, 1798
Watercolour
16½ × 21¾ in (41.9 × 55.3 cm)
V&A
FA 499

Fig. 23 Robert Hills
Farm Yard, c. 1804-10
Pencil and watercolour
8¼ × 11¹³/₁₆ in (21 × 30 cm)
V&A
D.492-1888

perhaps significant. Talbot, as the discoverer, needed to convey the wonder of the invention and promote what was unique about it with respect to other forms of image making. His title emphasises the marvel of the natural action – that nature literally draws herself – almost as if needing to defend himself against those who might not believe the new creation was not the clever trickery of a draughtsman or printer. It introduced knowingly from the very start the conundrum that photography is apparently unaided by the intervention of human hands. However, Turner's 'from Nature' acknowledges the autonomy of the photographic process, divorced from its subject. It has the ring of the term applied to a portrait painting or sculpture said to be taken 'from life'. It implies that the artist intervenes and works with nature to produce a recognisable likeness; but this likeness might be a starting point rather than an end in itself. Turner's intent was not to copy nature, or to let nature copy herself, but to mediate and transmit its image and, by observation, to distil its essence.

Talbot's publication was certainly influential. Yet his visual references were nevertheless founded in a wider context that still had currency when Turner developed his pictorial awareness. There are many comparable precursors for both the visual model and the intellectual foundations behind Turner's images. Like many of his upper middle-class contemporaries, he was no doubt familiar with the established topographical and picturesque tradition in the visual arts. The practice of making topographical and artistic landscape views, which were at least begun outdoors, had a distinguished history in Britain beginning in earnest from the 1750s with the work of Paul Sandby (1725-1809). His training as a topographical draughtsman for the military brought to the genre an edge of precision and a concern for veracity to nature. The early amateur photographers found affinities with their artist forebears such as Thomas Girtin (1775-1802), Cornelius Varley (1781-1873) and John Constable (1776-1837; fig. 31) who worked from the late eighteenth century through the early decades of the nineteenth with a new emphasis on naturalism. Girtin was one of the leaders of the revolution in watercolours in the 1790s. Although depicting actual locations like *Rievaulx Abbey, Yorkshire* (fig. 22), increasingly he suppressed detail in favour of a limited tonal range and breadth of handling – in many ways much like the natural effects of the paper-based calotype. Although artists such as Girtin established a tradition of depicting known locations, others such as Robert Hills (1769-1844) concentrated, like B.B. Turner, on humble farm scenes (fig. 23). The works of water-

Fig. 24 Cornelius Varley
The Market Place, Ross, Herefordshire, 1803
Watercolour
11⅝ × 18 in (29.6 × 45.7 cm)
V&A
108-1895

colour artists and printmakers like John Sell Cotman (1782-1842; fig. 28) and Peter De Wint (1784-1849; fig. 41) exploited both antiquarian and 'picturesque' subjects.

The term 'picturesque' has a specific meaning which applies particularly to a nostalgic sensibility towards landscape prevalent in the late eighteenth and early nineteenth centuries. Picturesque images are characterised by roughness, irregularity or intricacy in texture, features that were defined as pleasing to the eye. The picturesque tour of England became a matter of course for most artists depicting landscape subjects. These common interests prompted Hills and Varley among others to form the Society of Painters in Water-Colours in 1804. It was later joined by Cotman, De Wint and many of the leading watercolourists and became popularly known as the 'Old Water-Colour Society'. Cornelius Varley became absorbed as much in the science as in the art of draughtsmanship. In order to improve the ease of working outdoors he developed drawing instruments such as his graphic telescope (a kind of refined camera obscura, patented in 1811) which he used to make views such as *The Market Place, Ross, Herefordshire* (fig. 24). The image has an uncanny photographic quality in its secure handling of detail and in the way its complex perspective is rendered. It is inscribed 'Drawn on the Spot'. This inscription, as much as the emphatically placed clock tower at the centre of the image, shows how important it was for Varley to record that he was present in the scene depicted at the time that it was made. It points to a growing taste for first-hand observation and spontaneity. In the following generation photographers could fulfil this desire with much greater ease.[6]

B.B. Turner could have seen exhibitions of watercolours and paintings in London in a number of locations, including the Old Water-Colour Society and the Royal Academy of Arts. Exhibitors at the Royal Academy included some of the most influential and prolific British landscape artists, such as the photographer's namesake J.M.W. Turner (1775-1851) and John Constable. Both these artists also produced widely available sets of prints concentrating on landscape subjects: J.M.W. Turner's *Liber Studiorum* (1812) and Constable's *English Landscape* (1830).[7] Constable's set of prints has perhaps the closest parallels to the endeavours of the British amateur photographers of the 1850s. While J.M.W. Turner's *Liber Studiorum* was a compilation of artificially constructed landscape types, Constable's *English Landscape* was presented as an attempt to represent actual locations – often (as with B.B. Turner) with personal or family connections. It was not only their subject but also their monochrome appear-

ance and capacity for multiple reproduction that made such prints, perhaps more than watercolours, the nearest visual precursor to photographs. Constable chose the printmaker David Lucas to make mezzotints from his paintings and studies for *English Landscape*. The medium was especially suited to model fine gradations of tone. Constable, particularly noting his own interest in 'Chiar'oscuro' (Italian for 'light-dark') in nature, stated the aim of his publication in the introduction:

The immediate aim of the author in this publication is to increase the interest for, and promote the study of, the Rural Scenery of England, with all its endearing associations, its amenities, and even in its most simple localities; abounding as it does in grandeur, and every description of Pastoral Beauty … [the] aim being to direct attention to the source of one of its most efficient principles, the 'Chiar'oscuro of Nature' to mark the influence of light and shadow upon land-scape … also to show its use and power as a medium of expression… In some of these subjects of landscape an attempt has been made to arrest the more abrupt and transient appearances of the Chiar'oscuro in Nature: to shew its effect in the most striking manner, to give 'to one brief moment caught from fleeting time,' a lasting and sober existence, and to render permanent many of those splendid but evanescent Exhibitions, which are ever occurring in the changes of external nature.[8]

Benjamin Brecknell Turner could have used this passage appropriately to introduce his compilation of landscape imagery. Given the relatively instantaneous property of photography in relation to other manual arts, he would have been especially qualified to underline the idea of arresting the fleeting moment. The 'chiaroscuro' and differing tonal qualities of early photographs were celebrated in their time and also connected with the works of the Old Masters:

Our works are but monochrome studies; now golden brown, now of a rich reddish sepia tone; now grey and lucid, presently almost of a black Indian ink lustre, but still, in one form or another, monochromes, with all their merits and deficiencies, soft, even, beautifully modelled, rich-toned as Rembrandt, sweet and mellow as Correggio.[9]

B.B. Turner's photographs exhibit many of these subtle ranges of colours, perhaps selected specifically to suit particular subjects. Although he used Talbot's original negative process for all the images in *Photographic Views from Nature* Turner did not

choose Talbot's original method of salted paper prints – except on one occasion in the album (pl. 6). He preferred instead generally to use the newer albumen paper. Technical discussions and recipes for processes fill the pages of Turner's personal 'Photographic Scrapbook' and the journals of the period that dealt with photography such as *Notes and Queries, The Athenaeum, Illustrated London News, Photographic News* and *Journal of the Photographic Society*.[10] The photographic clubs and societies were also meeting points where the early amateurs could discuss such technical matters. As Grace Seiberling and Carolyn Bloore point out in *Amateurs: Photography and the Mid-Victorian Imagination* (1986) the environment of the Photographic Exchange Club to which Turner belonged also had much to do with their choice of subjects:

Since the organisation probably originated as an antiquarian exchange club, it is not surprising that the central group of images should be pictures of ruined abbeys, castles, churches, monuments like Stonehenge, Shakespeare's house, and Roman bridges which, in different ways, were reminders of the past and embodiments of aspects of England's History.[11]

Turner was by no means unique as a photographer in his choice of subject matter. British contemporaries such as Roger Fenton, Frances Bedford, Hugh Diamond, William Lake Price, George Shadbolt, Sir William J. Newton and William Sherlock, to name just a handful, dealt with much the same imagery. However, despite their initially similar appearance, many of the works of the most accomplished individuals exhibit unmistakably unique approaches and expressive qualities. Among this group Turner's pictures were often of a superior scale and he was consistently praised, from the very first recorded exhibition of his pictures at the Royal Society of Arts in 1852, as being one of the best practitioners of the Talbotype: 'For vigour of effect and general truthfulness, nothing can surpass the series of six pictures exhibited by Mr. B. Turner…'[12]

In addition to the precedents of pictorial artists, photographers of the 1850s are likely to have known of the ideas of the Romantic poets and to have been conversant with some of the contemporary explorations and debates in science. Even if not directly influenced by specific examples, such ideas were current in cultural life and filtered into the consciousness of Turner's stratum of society. Many of the locations that Turner photographed had been sites of poetic or artistic pilgrimage since the eighteenth century. They were steeped in historical significance. His other choices of

less well-known locations demonstrate his interest in and understanding of rural practices and his ability to translate what he saw into a pictorial form. Showing the actual conditions of farm labourers for example would not have been considered appropriate.[13] No doubt his choice of locations was also influenced by a mixture of basic practical considerations such as transport links, family holidays and weather conditions. From this background Turner set out to photograph the English landscape.

Unlike Talbot, Turner is not known to have left any correspondence relating to his images. Given the relative paucity of such literary documentation my approach will be to try and examine some of Turner's intentions as an image maker, partly within his own frame of reference. This methodology, albeit considered, often cannot be other than subjective, although I hope it will be less presumptuous than helpful in assessing his contribution to the art of photography. It is now worth considering some of his individual images in depth and comparing them with their actual locations in which contextual associations of history, topography and pictorial tradition come into play.

Worcestershire and Bredicot

Almost a third of the photographs that Turner selected for *Photographic Views from Nature* are concentrated in the West Midland county of Worcestershire. The area is characterised by broad plains and rich pastures broken occasionally by low hills. In the nineteenth century wheat was grown extensively, cattle and sheep were kept and orchards for cider making were cultivated. It was also famed for its porcelain manufacture and glove making cottage industry. At the centre of the county is the cathedral city of Worcester. The writer, politician and agriculturalist William Cobbett, in his account of the state of rural England, *Rural Rides* published in 1830, noted of Worcester: '… the *people* are, *upon the whole*, the most suitably dressed and most decent looking people. The town is precisely in character with the beautiful and rich country, in the midst of which it lies. Everything you see gives you the idea of real, solid wealth …'[14]

In 1837, the 'solid wealth' created by Turner's father-in-law, Henry Chamberlain – from his part in porcelain manufacture – allowed Chamberlain to bow out of the business, purchase Bredicot Court and turn to more rural pursuits. Bredicot village is

a cluster of cottages, a church, rectory and a few farm buildings about four miles to the east of the city. In 1851 five or six families, 65 residents in total, are listed as living in and around Bredicot parish, 12 of whom lived at Bredicot Court. They were farmers, farm workers, agricultural labourers, housekeepers and servants (two at Bredicot Court), a carpenter, a governess, a school-master, a rector and a railway porter.[15] As undoubtedly the first person to photograph and, in a sense, 'capture' the village at Bredicot, Turner must have felt as if he had a part in the ownership of his surroundings. This corner of rural England was the heart of his photographic activity.

The image of Bredicot Court and its life became one of Turner's photographic talismans (pl. 6). He used it in his selection for *Photographic Views from Nature*. Curiously, it is the only salted paper print in what is otherwise entirely a selection of albumen prints. Perhaps this was simply one of the earliest prints. But the impression is that he wanted to single this image out for an alternative treatment because of its importance to him as a subject. He used it again, this time as an albumen print slightly cropped at the left, as his contribution to *The Photographic Album for the Year 1855*.[16] In a text that accompanies this image on the facing page he noted 'taken by Fox Talbot's process in April 10 am in clear sunshine. Exposure 30 minutes.' Bredicot Court may have its origins in the early 1500s but the main structure is an early seventeenth-century half-timbered brick house of two storeys and an attic with a tiled roof added in the eighteenth century. The lower building to the right is a piggery which combines a low brick enclosure as an open run and a roofed structure for shelter. Piggeries were traditionally located close to farmhouses so that the pigs could be conveniently fed on household waste. However, Agnes Turner recalled that Bredicot Court's previous inhabitants did not even need to make this short journey. The farmer, his wife, children and the pigs lived in the kitchen.[17]

Turner was able to make a remarkable variety of views at Bredicot considering its small size and how little he actually moved his photographic apparatus within the area. By making pictures in both summer and winter, and by subtle but effective repositioning of the camera, he coaxed the village to yield a surprising number of visual aspects and evocative atmospheres. When the details are observed the layout of the village begins to fit together.

The same piggery in *Bredicot Court* can be seen again to the right in *Foldyard, Bredicot Court, Worcestershire* (pl. 8). While the bare trees in the view of the house indicate that the photograph was made not long after the winter months, *Foldyard, Bredicot Court* is

redolent of summer. The atmospheric effects of aerial perspective are evident in the backdrop of the gently rising land with its detail lost in a warm, golden haze, enhanced by the honey colour of the print. The evidence of agricultural activity also helps to pinpoint the season. A foldyard is usually where cattle are kept in winter, but here it is being utilised for a different purpose. Hay, cut in the summer months, has been heaped here prior to being stored in the barn ready to feed the animals through the winter. The opposite end of the large barn, with its distinctive brick foundation, timber walls and thatched, hipped gable roof, can be identified as the taller structure emerging on the left in *Bredicot, Worcestershire* (pl. 5). The lane, photographed here in dramatic, plunging perspective, is an ancient public carriage road which was, and is still, the only route into and through the village. On the opposite side of the lane to Bredicot Court and its foldyard, to the right just out of view behind the thatched structure, stood the second largest dwelling in the village. The L-shaped half-timbered house dates probably from the sixteenth century but was restored with brickwork on its end wall in the eighteenth century. Its compact but interesting shape made it a subject that could be satisfyingly photographed from a variety of aspects. Turner showed it from both front (pl. 9) and back (pl. 10). Somewhere towards the back of this house a timber framed dovecote once stood (pl. 7). The structure is shown in winter when it would have been at its most useful.[18] Doves or pigeons were kept for their fresh meat and eggs to vary the limited diet of mediaeval times or to supplement other food supplies when they ran low. The birds, which nested in slots built along the tall inside walls, were reached by a ladder. Their droppings were collected and utilised as manure. By the nineteenth century most new dovecotes were built as decorative features. This ancient example may have been in use as a store of some kind by the time Turner photographed it. Rustic paraphernalia adds interest to the scene: the thatched shelter in need of repair, the tip-cart on the right with its interesting pattern of spokes and, leading the eye into the foreground, a flat roller for compressing earth with logs placed on top to add extra weight.

By the 1850s the rural character of the county, its landscape unchanged for many years, was seeing the effects of the profound changes brought about by the Enclosure Acts and the coming of the railways. Enclosure, instigated by numerous Acts of Parliament since the second half of the eighteenth century, allowed the common lands of a parish to be divided amongst private owners. The lands connected to Bredicot were subject to enclosure in 1846.[19] Despite such changes the 1850s were a

time of relative agricultural prosperity. This 'golden age', from about 1850 to 1865, was ideally placed in a transitional period without parallel in agricultural history; it was able to make good use of modern machinery, which was more productive than the older farming methods of the first half of the century, but it had not yet reached the steep agricultural decline of the second half of the century when England's economy became increasingly urban. Part of the land which would normally have been allocated during enclosure to Henry Chamberlain was given over to the Birmingham and Gloucester Railway Company to construct a railway bridge behind Bredicot Court.

The first train to reach Worcester came in 1850, although by then some of the county had already been traversed by track cut through fields. Between 1839 and 1840 the railway from Gloucester to Birmingham cut Bredicot village in half. The church where Turner was married[20] (fig. 8) and rectory are situated literally on the opposite side of the tracks from the houses and are accessible only across the railway bridge just a few steps behind Bredicot Court. The novelty of the railway was compelling. Turner's wife, Agnes, wrote: 'Great was the excitement of the railway works; and the first engine that came along was a jubilee! Dampened somewhat by raids by the navvies into the poultry yard and, worse still, on the game.'[21]

This excitement did not, however, prompt Turner to photograph the railway. Yet its presence could not be easily ignored. The present occupants of Bredicot Court recall that, even in the 1930s, smoke from noisy steam trains filled the farmyard. Turner could not fail to notice the impact of the railway – but he chose not to acknowledge it in his art. The converging lines of track did not appeal to him in the same way that they appealed to one of his great French contemporaries, Édouard Baldus (1813-89).[22] Turner consciously shunned the contemporary world that had arrived on their doorstep at Bredicot. The country was a place to go shooting, to relax with the family and to photograph the signs of a reassuring older order. This was the kind of view of the country accepted by many middle-class Victorians and articulated by William Howitt in *The Rural Life of England* (1838). In two volumes of nationalistic and celebratory commentary, he elaborated upon nostalgic subjects with headings such as 'midsummer in the fields', 'country sports', 'old English houses', 'the delightfulness of country residences', 'cottage life', 'bell ringing', 'wrestling' and 'beer drinking'. A self-portrait by Turner, of which only a negative is known, taken at the back of Bredicot Court (fig. 25) shows him confidently seated like

Fig. 25 B.B. Turner

Self-Portrait at Bredicot Court, c. 1852-60

Calotype negative, waxed

$11^{11}/_{16} \times 15^{13}/_{16}$ in (29.7 × 40.1 cm)

The Royal Photographic Society, Bath, England

17954

a country squire.[23] His pose and attire (hand on hip and wearing a peaked cap) are similar to those in the self-portrait taken drinking wine outdoors with Henry Chamberlain (fig. 10). A dog kennel to the right, a cider barrel and stack of long pieces of timber for fencing to the left point to country pursuits. There is no evidence to show that a few steps behind where Turner placed his tripod trains thundered past.

The only photograph that contains a figure in *Photographic Views from Nature* is *Hedgerow Trees, Clerkenleap, Worcestershire* (pl. 46). It shows a man leaning casually but sturdily against a fence and pollarded oak tree. The fence has been built in the old-fashioned way with timbers of hand-cleft, rather than machine-sawn, oak following the natural grain of the wood. The ancient trees are heavily cut back or pollarded to promote the growth of new, slim branches used perhaps for firewood, brooms or weaving into baskets.[24] Visual interest hinges on the V-shaped forms of the paired trees which echo one another. Wood from these trees was probably used to make the fence. This photograph is more than a country scene of ancient oaks and time-

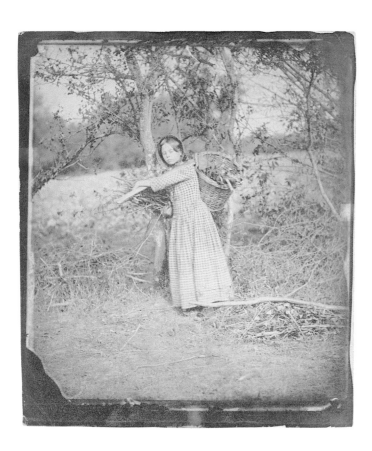

Fig. 26 Attributed to William Sherlock
Girl with Basket of Firewood, 1850s
Salted paper print
10¼ × 8¹¹⁄₁₆ in (26 × 22 cm)
V&A
43-1979

honoured rural skills, its implied theme being the cycle of nature, pairings and perhaps companionship. Although the figure appears clean shaven and wears a peaked cap similar to the one worn by Turner in figs 10 and 25 it is difficult to say with certainty whether it is Turner or not. The lack of detail in the face, due to strong contrast and the slight blur of movement most evident in the right hand, make a positive identification impossible. Yet it is tempting to conclude that this solitary figure within a selection of 60 photographs is significant. Turner was not averse to using himself to add interest to a scene, and he had done so before. Moreover, he could trust himself to hold a pose for the length of time necessary for exposure and thus neatly signal his authorship with his own presence.

Even allowing for technical difficulties Turner's choice largely to show scenes without people is certainly a conscious decision. His many informal portraits of family and friends perhaps satisfied the need to record the people who mattered to him.[25] However, in his rural scenes made for exhibition the decision to exclude figures is something of a departure from established tradition. So-called *staffage*, or accessory figures, were usually placed in landscape and architectural paintings of the period. Even when not immediately obvious, figures can be picked out. For example, a man wearing a hat looks up under one of the arches in Girtin's *Rievaulx Abbey, Yorkshire* (fig. 22) and in Cornelius Varley's otherwise deserted street scene, *The Market Place, Ross, Herefordshire* (fig. 24), a man sits at the window of a building to the left with his horse tethered outside. Whole sets of prints such as William Pyne's *Microcosm* (1806) were produced specifically for artists to copy and import farm labourers, villagers and rustics into their compositions. Close contemporaries who exhibited alongside Turner, such as William Sherlock (b. 1813), often chose to show animals and figures in rural settings (fig. 26). In Turner's photographs humanity is evident not through its presence but rather through the evidence of its actions and interventions in landscape and architecture. Excluding figures in their contemporary clothes makes the period less historically specific and allows, simultaneously, the possibility of nostalgic projection and a timeless quality.

Despite the eerie lack of figures in Turner's formal photographs, back home at Bredicot Court the location remained very much alive. Some of the buildings in the surrounding areas were not as fortunate. Crowle Court stood in the next parish (pl. 12). A superbly suggestive negative (an alternative view of the Court from the one he selected for *Photographic Views from Nature*) shows Turner's taste for picturesque decay

Fig. 27 B.B. Turner
The Round Church, Ludlow Castle, 1852-4
Calotype negative, waxed
11¹¹/₁₆ × 15¹³/₁₆ in (29.7 × 40.1 cm)
The Royal Photographic Society, Bath, England
17805

evident in the dilapidated state of the building. The near ruin is caught by the camera as a parting glimpse of the mediaeval past. The Court, which was situated on a moated site (at first a defensive necessity but later a prestige feature), was built as the manor house of the priors of Worcester. The structure was destroyed in the 1860s.[26]

Ruined castles and abbeys

The moat at Crowle Court was a reminder of the need at one time to defend this volatile western border country from the Welsh. One of the main defensive positions was Ludlow Castle (pls 15-18). Many castles were built on the English borders to secure the country and enforce the king's rule after the Norman invasion and the subsequent victory of William the Conqueror in 1066. Work on construction at Ludlow started around 1086, although building continued during subsequent centuries. Throughout its long history the royal castle had been a centre for provincial rule. During the Civil War of the seventeenth century it was defended for the king but surrendered in 1646. Soon after it was deserted and fell slowly into decay. By the 1770s a surveyor was sent to see if demolition was a practical proposition. His report suggested that the cost of demolition would be greater than the profits to be made from the sale of salvaged materials.[27] So the ruin stood, gaining popularity with succeeding generations of tourists and artists in search of the picturesque.

The original Norman invaders imported their own architectural style. An excellent example is the round chapel of St Mary Magdalene at Ludlow built in the early twelfth century (fig. 27). Turner also photographed close up the richly ornamented doorway with its characteristic zigzag 'dog tooth' carving (pl. 18). The artist John Sell Cotman made a feature of Norman doorways in his set of etchings *Norman and Gothic Architecture in the County of Norfolk* (1816-18; fig. 28). Cotman astutely aimed his sets of prints at the scholarly antiquarian audience, while by introducing a picturesque treatment he ensured that they could also be appreciated by the non-specialist. The visual vocabulary of such volumes of prints may have filtered down to Turner and informed his own choice of a close view point. Yet the photographic medium adds an extra dimension. The camera could, of course, record minute detail but it could also render the natural qualities of real daylight falling on stone. This was something that even the most naturalistic draughtsman could not match. It was this mixture of precision and atmospheric quality in photographs of architecture that Henry Cole,

Fig. 28 John Sell Cotman

A Doorway, South Side Shingham Church Norfolk, 1811

Plate 10 from *Norman and Gothic Architecture in the County of Norfolk* (1816-18)

Etching

9¹³/₁₆ × 7½ in (24.9 × 19 cm)

V&A

E.3104-1902

the director of the new South Kensington Museum, was to dub 'suggestiveness'.[28] In Turner's photograph strong directional light picks out detailed ornament yet throws the portal itself into deep shadow. Concentration on the unavoidable gaping darkness makes this image less of an attempt to record an architectural feature and more of an emotive statement about standing poised on a threshold and gazing into the unknown. The motif of the forbidding or enticing entrance or gateway recurs throughout *Photographic Views from Nature* as if to punctuate the visual journey with points of entry and departure, as in *Gateway, Cathedral Yard, Peterborough* (pl. 13), *Ludlow Castle, Causeway and Entrance* (pl. 17), *Entrance Gateway, Loseley House* (pl. 37) and the open barn doors in *At Compton, Surrey* (pl. 32).

As a contemporary guidebook points out, Ludlow Castle remained perhaps more in the Victorian popular imagination than other castles because of its association with the esteemed seventeenth-century English poet John Milton.[29] Milton's masque (a spoken performance set to music) *Comus* was first acted out at Ludlow before King Charles I. Notwithstanding such illustrious historical associations, the site was also one which showed '… a full union of those features in rural scenery which constitute picturesque'.[30] It was tailor made for the photographer. The guide continues to extol features such as: '… the bold masses of light and shade produced by deep retiring breaks; the rich tints and stains of age; the luxurious mantling of ivy and the sullen stillness that now reigns throughout these forlorn and deserted towers…'[31]

The guide goes on to note that 'the effect of the whole is calculated at once to awaken the enthusiasm of fancy and to diffuse the calm of contemplation'.[32] Turner's images, like a visit to the castle, operate within similar varied levels of prescribed responses. The educated audience for his photographs in the 1850s, such as his peers in the photographic clubs and societies, would appreciate his technical skill. They might have noted that, with appropriate textured qualities, the paper negative had rendered the patterns of stone and ivy and the satisfying silhouette of the battlements and gable ends. They may have commented on the way Turner chose (unusually for him) to trim the top of one print to an arch – a familiar compositional format used in this case to hide a defect at the edges of the negative (pl. 16).[33] Turner's approach to photographing the site is characteristic of his working methods. He almost stalks its different aspects, establishing the setting and orientating the viewer and then gradually moving closer. He displays a penchant for closing in on a detail and cropping it closely up to the edge of the print so that an almost two-dimensional flat patterning

and juxtaposition of textures becomes the main focus (pl. 17). Aside from such photographic considerations his audience would also be expected to be familiar with the responses elicited by the subject: feelings of historical awareness, antiquarian understanding, picturesque pleasure, imaginative musings and calming meditation.

Probably while on the same visit to Ludlow, Turner took advantage of the town's superb examples of seventeenth-century half-timbered houses. One of the most celebrated is the Feathers Hotel, built in 1603, which still stands (pl. 14). In the 1850s the preservation of Tudor and Jacobean buildings like the Feathers was not so secure. The sense that such things should not be taken for granted might have spurred many amateur photographers to document similarly fine examples of vernacular architecture.[34] At the Photographic Society of London exhibition in 1855 Turner exhibited a photograph entitled *Ludlow, Old and New Style*. As he occasionally re-titled his pictures with more evocative descriptions for exhibition this may have been the view of the old-style Feathers Hotel contrasting with the relatively new and plain style of the building next door. Much of the decorative quality of the Feathers is brought out by the contrast with its more dowdy neighbour. In some ways this type of didactic visual contrast is reminiscent of the architect A.W.N. Pugin's publication *Contrasts* (1836), which set out to compare British mediaeval structures with their apparently less worthy modern counterparts. Although Pugin's underlying project was a plea for Catholicism, which he associated with the mediaeval Gothic style, both Turner and Pugin's contrasts draw upon feelings of nostalgia and a concern for preservation.

The view is probably from a second-floor vantage point, no doubt from the window of a neighbouring property. The undiscriminating camera records with equal precision the decorative timbers and leaded window panes as well as the sign proclaiming the name of the hotel and shop signs to the left like the 'General Grocery Warehouse', 'M&C. Pillinger London Tea Agents' and the board above the archway stating 'Feathers Inn Neat Flys, Gigs & Saddle Horses'. The board has been brutally cut down, presumably to permit tall coaches to enter. Turner rarely allowed clues of contemporary commercial society such as signs to enter his photographs. Where they can be detected in his work they give a prosaic reminder of the times. There are posters and signs advertising ironmongers, haircutters, pubs, banks, life assurance, cattle stock sales, poetry readings and a performance of *Macbeth*.[35]

Ruins like those of Ludlow Castle have a long history as subjects for artists. England is equally rich in ruined abbeys as it is in castles. Thomas Girtin's *Rievaulx*

Fig. 29 *Whitby Abbey. View from the South West* from *The Monastic Ruins of Yorkshire from Drawings by William Richardson with Historical Descriptions by the Revd. Edward Churton, Lithographed by George Hawkins,* vol. 1, 1843
12 × 18¹⁵/₁₆ in (30.5 × 48 cm)
V&A National Art Library
L.51-1900

Abbey, Yorkshire is a typical example in the English watercolour tradition (fig. 22). Such grand ruins suggested simultaneously the ingenuity of man and the weakness of his labours under the onslaught of time. They were deeply suggestive of the past and consequently bound up with important events in national history. Most of the abbeys in England and Wales fell into ruin as a result of the religious and political Reformation under King Henry VIII, when he wanted to break from the Roman Catholic Church and the pope. As head of the English Church he brought about the suppression of the monastic houses of England and Wales and the transfer of their property to the crown in an effort to boost royal income. As a result, from the mid-1530s, many abbeys were converted to cathedrals, surrendered to the new owners of the monastic estates, dismantled and plundered for their building materials or abandoned and left to ruin.

The county of Yorkshire in the North of England has a particularly rich concentration of ruined abbeys. Yorkshire is the northernmost location represented in Turner's photographs selected for *Photographic Views from Nature* and is a considerable distance – about 250 miles – from his usual locations in the South and South-west of England. Although the Yorkshire ruins became popular destinations for the Victorian tourist, and towns like Whitby developed as such, they were also sites of antiquarian pilgrimage. Publications illustrating this area were produced with part topographical and part artistic lithographic prints: *Whitaker's Abbeys and Castles in Yorkshire* (1820) and Richardson's *The Monastic Ruins of Yorkshire* (1843; fig. 29). The first

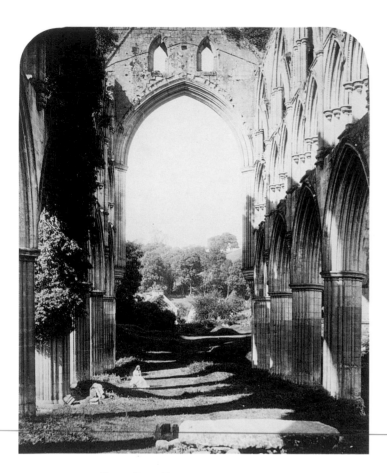

Fig. 30 Roger Fenton
Rievaulx Abbey, Yorkshire, 1854
Albumen print
13⁹/₁₆ × 11¹/₄ in (34.4 × 28.6 cm)
V&A
Ph.12-1978

serious photographic publication on the subject was Philip Henry Delamotte and Joseph Cundall's *A Photographic Tour among the Abbeys of Yorkshire* (1856). Before this however, around 1854, both Turner and Roger Fenton made photographic 'fine art' views of Rievaulx Abbey intended for exhibition. Ruins allowed a photographer to make an exposure in full daylight of what would once have been a dimly illuminated internal architectural space. Whereas Fenton's view makes play with the shadows of the columns and looks down the centre of the nave (fig. 30), Turner's picture closes in upon the repeating forms of the overlapping arches and looks across the ivy-clad side of the Gothic choir (pl. 45). Both photographers make a feature of integrating the landscape beyond framed naturally through the arches.

Although Turner photographed abbeys in the area like Rievaulx, Fountains, and – back in his more usual territory of Worcestershire – Pershore (pl. 19),[36] Whitby was the location that captured his imagination. Its origins lay in a religious house set up on the coastal headland in 657. A Norman church, built on the site in the 1070s, proved inadequate under the pressure of pilgrims, and rebuilding commenced in the 1220s. From that time the abbey housed about 40 Benedictine monks. They surrendered the abbey to the commissioners of King Henry VIII in 1538, after which the building was abandoned and fell into ruin. The gaunt remains are set high on a cliff-top overlooking the town and harbour. It is approached from the town by climbing 199 steps.

Turner's intense scrutiny of the abbey resulted in a fine series of views, six of which he printed in his album. He also exhibited five views of Whitby and one of Rievaulx at the Photographic Society of London exhibition in 1854. In his original album sequence he grouped the views in a way that suggests, as at Ludlow Castle, a slow zooming in on the subject from a distance. The first view is the most distant, placing the imposing monument in the context of its isolated surroundings (pl. 41). The following views progress towards dramatic cropping of the architectural forms. One draws attention to the pointed silhouettes of the jagged skyline (pl. 42), another highlights the broken columns and piles of debris (pl. 43). In the last image the windows are reduced to thin lancets of light. Almost all sense of linear perspective is flattened out and all areas of the print, from side to side and top to bottom, are equally important and dense with information (pl. 44).

The interest that crumbling, ivy-covered ruins like Whitby exerted on artists like Turner led ironically to an increased appreciation of the sites, which in turn led to

their preservation. A guide to Whitby published in 1850 notes how less than 20 years before major parts of the building were still collapsing into a ruin. The tower, which was 104 feet (32 m) high, collapsed in 1833.[37] Turner showed the rubble at the site (pl. 43). The Whitby guide, echoing the sentiments in the Ludlow guide, opens with a poetic evocation of the idea that man needs to witness changes like 'growth and decay', the 'seasons', and 'the dash of the sea' in order to maintain a healthy physical and mental existence.[38] Further, such sights of nature 'assuredly purify and refresh both soul and body'.[39] The implication is that Whitby, possessing both an ancient ruin and close proximity to the sea, is a perfect environment to observe change and to improve physically, mentally and spiritually.

This dialogue strangely lacks any overtly Christian overtones considering the distinguished ecclesiastical history of the site. However, it does offer a secular alternative emphasising an holistic approach to healing mind, body and spirit through contemplation and physical experience. Skirting religious issues in this way anticipated the increasing discomfort surrounding questions of Christian beliefs brought to a head in the light of scientific advances such as Darwin's theory of evolution outlined in the *Origin of Species* (1859). A neutral form of faith in nature, which could also give enriched meanings to human experience, could stand in the interim as the debate continued. An art like Turner's was not directly about recording information but often about contemplating change within nature and the implied human position within such changes. The experience of looking at the image as a viewer, mediated through an attuned, concentrated level of contemplation by the photographer, might contain a short cut to the kind of restorative and purifying properties implied and extolled in particularly appropriate locations.

This kind of idea was not new in 1850. It was one explored by the English Romantic poets and perhaps most succinctly expressed by William Wordsworth in works like 'Tintern Abbey' written in 1798.[40] Wordsworth's poem describes memories of a visit to Tintern Abbey that console him in more urban settings and generate moods of calm awareness and almost mystical insight, where 'we see into the life of things'. The mind receives visual stimuli from nature but also half creates, by its own operations of memory and imagination, the scenes before the eyes. Turner's best photographs on a particular subject or motif, like Wordsworth's imagery, can be read as lyrical meditations. The choice visual ingredients that are best suited to reverie have been pre-selected by the artist. In the process of meditation nature itself,

although acting as a focus or catalyst, becomes almost inconsequential.

One ancient castle site that avoided falling into total ruin was Arundel in Sussex. Despite having the traditional appearance of an ancient castle, signalled by its towers and battlements, the part of Arundel photographed by Turner was barely 50 years old at the time (pl. 39). Although some of its eleventh-century origins remain, the site was subject to continual restoration and rebuilding. Much of this was carried out in the eighteenth and nineteenth centuries. At the end of the eighteenth century several landowners turned to castle building or restoration. Many of them were attracted to the castle style because of its traditional and feudal associations or because it represented 'ancient liberties, trial by jury, and the moderating influence of the barons on the royal prerogative'.[41] Certain architectural styles from particular periods in British history (such as the eleventh-century Norman, then so-called 'Saxon', and the fourteenth-century Perpendicular Gothic) were associated with these ideas. At the start of the nineteenth century at Arundel Castle, the owner, the 11th duke of Norfolk, decided to build a new wing using a combination of these styles. He consulted historians and antiquaries but placed himself in charge of the design. In an attempt to suggest chronological development he placed 'Saxon', with its solid, rounded arches and 'dog tooth' carving on the arches, on the ground floor and Perpendicular, with its attenuated vertical lines and tracery, on the upper. Dominating the east wing was a Coade stone relief modelled by J.F.C. Rossi showing *King Alfred instituting Trial by Jury on Salisbury Plain*.[42] Comments about this hybrid structure, completed in 1801, were almost universally disparaging. The painter Constable visited in 1843 and found parts of the castle 'vulgarised' and 'hideous'. Another commentator writing in 1839 noted:

Arundel Castle … was for many years the scene of the late Duke of Norfolk's trials at building; by which, as his own architect, he sought to instruct himself in the gothic style. After being occupied in this way for upwards of forty years, and spending several hundred thousand pounds, he just arrived at last at that point where a man discovers his own utter ignorance … [this] suggests that the Duke should have employed an architect rather than 'realising' the crude ideas of his own mind.[43]

Such adverse criticism did not stop visitors to the castle, who had been able to view select parts open to the public since the late eighteenth century.[44] When Turner photographed there in the early 1850s perhaps extra incentives to visit were provided

by its connection with the recent stay of Queen Victoria and Prince Albert, a new rail link and a revised guidebook produced in 1851 to coincide with the Great Exhibition.[45] It was thought that some of the visitors to the Exhibition might make the day trip to Sussex. However, the idiosyncratic new east wing lasted only 70 years, for it was demolished in the 1870s to be replaced by a more 'gothic' construction.[46]

Turner is not known to have been interested in making narrative figure compositions or historical tableaux in photography like others of his contemporaries such as William Lake Price (1810-95), Henry Peach Robinson (1830-1901) or Oscar G. Rejlander (1813-75). However, Turner's photograph of the relief sculpture at Arundel allowed him to incorporate an historical narrative subject without resorting to using actual figures. Such historical narratives were considered in the cultural canon of the time to be the most appropriate aim of high art. The subject, Alfred the Great, the ninth-century king of Wessex, was renowned for his defence of England against the Danes, his institution of legal codes and his encouragement of learning. Within the context of Turner's other pictures in *Photographic Views from Nature* – showing a cross-section of typical and celebrated English landscape and architectural types – Alfred stands as an apposite human symbol of English historical lineage and patriotic native values.

Windmills and Amsterdam

When Turner photographed the windmill at Kempsey this spot had been a favoured site for windmills for over 500 years[47] (pl. 20). It lies a few miles south of Worcester on an area of high ground ideally placed to make best use of the winds that blow from the direction of the Malvern Hills and across the open fields. The location was in fact notoriously windy. In 1802 a hurricane blew the sails of the windmill round with such rapidity that it was set on fire.[48]

However, by the 1850s the long service of windmills as an efficient means of grinding grain was drawing to a close. Turner's tower-mill has a wooden top which would have rotated – by means of the wheel set into it being turned by the pulley rope attached – to allow the sails to face into the changing direction of the wind. The sails lack a substantial amount of canvas. This was a sign that the building was even then not in use, at least for its original purpose. These ingenious and attractive devices could not compete with the mechanised mass-production techniques of the

Fig. 31 John Constable

A Windmill among Houses, with a Rainbow c. 1824

Oil on paper laid on canvas

8¼ × 12 in (21 × 30.4 cm)

V&A

126-1888

new, larger steam-driven mills. The mill shown in Turner's photograph was probably the last to stand there. It was demolished about 20 years after the photograph was taken.[49] Today a few hints of the windmill's presence still exist. The brick cottage to the right of the picture survives in Mill Lane. In a garden close by – enclosed by a wall made from small, old bricks probably salvaged from the ruin – lies a millstone, much like the one that leans next to the open door in Turner's picture.

The windmill has a good pedigree as a subject for artists. The tradition was established during the seventeenth century by painters working in Holland, the country with which the windmill is most strongly associated. For these artists the cruciform shape of the sails contained a religious symbolism. As Timothy Wilcox has pointed out, 'the dependence of the mill on the power of the wind was used as an image of the soul's need for the Holy Spirit to give it life, or more generally of the presence of God at work in the world.'[50] Rembrandt's painting *The Mill* was copied in prints and provided the influence for drawings, watercolours and paintings for a generation of British artists who began depicting windmills in abundance after 1800.[51] One of the most talented devotees of the subject was John Constable who, like Rembrandt, was

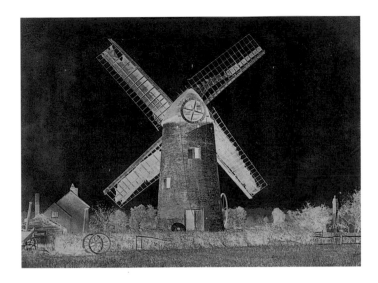

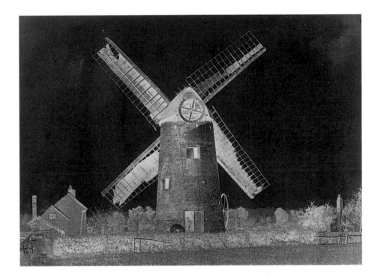

Fig. 32 B.B. Turner

Windmill, Kempsey, Worcestershire, 1852-4

Calotype negative, waxed

11¹¹/₁₆ × 15¹³/₁₆ in (29.7 × 40.1 cm)

The Royal Photographic Society, Bath, England

17868

Fig. 33 B.B. Turner

Windmill, Kempsey, Worcestershire, 1852-4

Calotype negative, waxed

11¹¹/₁₆ × 15¹³/₁₆ in (29.7 × 40.1 cm)

The Royal Photographic Society, Bath, England

17869

the son of a miller (fig. 31). As well as drawing from a long tradition of windmill imagery, Turner clearly delighted in the precision of the camera to record detail that allowed a particular kind of compositional play. The right angles of the ends of the sails align with the forms of the rooflines of the cottage to the right of the pl.20 picture, and the numerous circular shapes of wheels and millstone imply the motion of the sails.

Four different negatives of the subject survive (figs 32-35).[52] At first glance they appear to be almost identical. However, close inspection reveals how Turner grappled with the composition by making subtle changes until he was satisfied. His aesthetic judgment can be decoded by comparing the negative variants with the final version that he chose to print for *Photographic Views from Nature*.[53] All four negatives contain some of the same basic elements: the centrally placed windmill and, on the left, a house, plank shed, a trailer and two chimneys – one stone built, the other a metal cylinder possibly from a steam engine of some kind. To the right is a low cottage with its chimney rising among the trees. Grass and a hedge cross the foreground. The negative illustrated in fig. 32 is the one from which the print used in *Photographic Views from Nature* was made (pl. 20). On the foreground grass is a pair of cartwheels joined by an axle. In fig. 33 the pair of cartwheels has been removed but a figure in a smock, possibly the miller himself, has appeared in the mill's ground-floor entrance. The metal chimney has now become an after-image, possibly manhandled out of shot

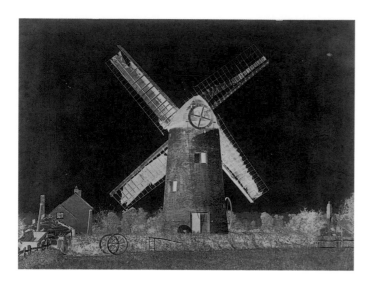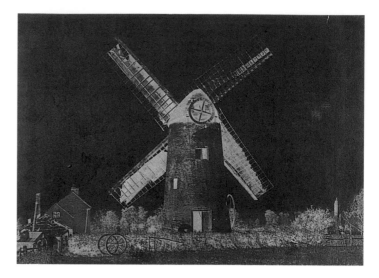

Fig. 34 B.B. Turner

Windmill, Kempsey, Worcestershire, 1852–4
Calotype negative, waxed
11 $^{11}/_{16}$ × 15 $^{13}/_{16}$ in (29.7 × 40.1 cm)
The Royal Photographic Society, Bath, England
17870

Fig. 35 B.B. Turner

Windmill, Kempsey, Worcestershire, 1852–4
Calotype negative, waxed
11 $^{11}/_{16}$ × 15 $^{13}/_{16}$ in (29.7 × 40.1 cm)
National Museum of Photography Film and Television, Bradford
1886-10

during the long exposure. Fig. 34 retains the foreground wheels and dispenses with the figure but the chimneys have been brought into alignment by moving the camera slightly to the right. The chimneys now overlap and read as one vertical. Fig. 35 appears to differ from fig. 34 only by another movement of the camera a couple of paces closer to the subject – plus some blurring over by the trailer, which suggests a moving figure. This sequence shows how Turner intervened in what looks like an apparently naturalistic scene, moving elements and then the camera as if setting a stage. He showed his understanding that the camera notes every detail and he worked with this peculiarity to create the look of ordered disorder he required.

One of the reasons why Turner might have been so discerning about the use of subtle and fractional shifts of camera placement in this instance could have been his experience of making 'Wheatstone' stereographs.[54] These consist of two photographs of the same subject taken from slightly different angles – a matter of shifting the camera about 6 inches (15 cm) from one exposure to the next. Two mirrors are placed at right angles to each other and the photographs are sited on either side facing inwards and parallel to the line of sight. When the viewer places his or her nose in the junction of the two mirrors and looks straight ahead he sees only one reflected image with each eye but has the illusion of seeing a single, three-dimensional image.[55] If Turner made many photographs for the Wheatstone stereograph, very few are known to survive. One of the rare examples is of the Windmill at Kempsey.[56]

Turner's use of the device might also have influenced the way in which he placed elements even within his compositions that were not intended for the stereoscope. The stereoscopic effect of his regular calotypes was noted by his contemporaries.[57] Stereoscopic images work best when overlapping elements are strongly lit and boldly situated to demarcate the foreground, middle ground and background. This aids the illusion of mass and recession in pictorial space. The effect has been described as a set of 'zones imbued with a hallucinatory clarity'.[58] Certain images by Turner amply meet the compositional requirements and optical quality of stereoscopic images, for example *At Compton, Surrey* (pl. 32).

The opportunity to pursue the subject of windmills arose in 1857 when Turner visited Amsterdam. However, his 16 surviving views of the city concentrate exclusively on the canals.[59] Turner was well travelled before visiting Holland. He had been to Belgium, Switzerland and Paris in 1840 and Switzerland, Munich, Salzburg, Vienna, Prague, Dresden, Berlin and Hamburg in 1845.[60] However, these travels pre-date his first involvement with photography and no foreign views are known to survive of any other locations apart from the Netherlands.[61]

Turner set out on a photographic tour of Holland in the company of his brother-in-law Humphrey Chamberlain. In his memoirs Turner's son recounted his father's misfortune at the hands of curious locals. This incident might explain why the excursion yielded relatively few pictures:

Nobody there had seen a camera before, and everyone was so excited that they hustled the poor man and nearly tumbled him into a canal. In the scuffle, his box of diaphragms *did* take the plunge, and the photography was at an end for that trip. Some half dozen fine photos of Amsterdam survive to tell the tale.[62]

Turner's surviving Amsterdam views are remarkable despite being few in number. They comprise some of the earliest known photographs of the city. Only a handful of other views from this time by Dutch photographers, among them Eduard Isaac Asser, Pieter Oosterhuis, and Jan Adriaan van Eijk, are known to survive.[63] Turner's views were the first coherent series of large format cityscapes made for a fine art market, rather than topographical record photographs or the more ubiquitous stereographs of the city, produced in the 1850s and aimed at the tourist. His chosen vantage points do not generally correspond with the topographical canon of the

time. The subjects are to the west of the city around the Keizersgracht canal but do not concentrate on specific buildings or important monuments. Instead he relished the naturally pictorial quality of the canals which emphasise perspective with their elegant terraced residences, tall warehouses with opened shutters, varied gables, boats, bridges and reflections in the water. Turner seems to have imported an English picturesque style and mode of looking into a typically Dutch cityscape. Other incidental detail adds interest: pl. 22 is a negative which shows the area known as the Rokin, with construction work on the bridge and scaffolding raised on one of the houses dating the picture to sometime after 11 May, but before 3 June 1857.[64] A view of the *Nieuwezijds Achterburgwal by the Hekelveld* (pl. 21) shows, on the left, barrels stacked up on the canal side with the after-images of figures wearing aprons loading or unloading them from cellars. A print from this negative has the figures painted on to reinforce their shapes since their trace is blurred on the negative due to movement during the exposure. The much-faded print was given to the Dutch Royal Society of Antiquarians in 1915.[65] Its presence in a Dutch collection early in the twentieth century suggests that it had perhaps been sold or acquired in Amsterdam shortly after it was made. The print may have been purchased in 1858 when an exhibition of photographs was held at the Industrial Society, the Vereeniging Voor Volksvlijt, Amsterdam. The catalogue lists eight views of Amsterdam by 'an English artist'.[66] Turner was evidently pleased with the results, for out of eight pictures he exhibited in London that same year four of them were views of Amsterdam.[67]

Rivers and the sea

From the 1790s, along with the Dutch-influenced British artists of the picturesque, the English Romantic poets were to a large extent responsible for the increasing popularity of visiting locations in England for sensory inspiration and spiritual enlightenment. Lynmouth, a village on the Devon coast, was one such magnetic location (pl. 3). Shelley, Wordsworth and Coleridge all visited. The proximity to the sea certainly had an effect on poetic minds. Wordsworth recounted how Coleridge planned the poem *The Rime of the Ancient Mariner* while in the area. Shelley is reported by his biographer to have appeared as a 'boyish figure on the Lynmouth beach launching a little flotilla of dark green bottles, tightly corked'.[68] They contained pamphlets advocating revolution.

Although popular, the village was difficult to reach. The railway did not arrive until 1898. In the 1850s this was a select place for discriminating visitors who arrived by coach or steamer from Bristol. Turner photographed the Italianate holiday villas of Lynmouth with their balconies overlooking the river Lyn that flows through the village. It is probably the same river with its similar cascade of rocks that Turner photographed nearby in a location he called *Lyndale, North Devon* (pl. 4).[69] He focused diagonally downwards on the river, creating a monumental close-up. This image was made at about the same time that the writer and artist John Ruskin was famously portrayed by John Everett Millais in *John Ruskin at Glenfinlas* (1854) standing by a similar rocky cascade.[70] The setting was intended to make an explicit connection with Ruskin's then highly current ideas which led him to entreat artists to return to the close observation of nature. Among the many branches of natural history explored by Ruskin, it was geology that he pursued most assiduously. Turner's photograph, perhaps like Ruskin's drawings, sought not simply to show geological phenomena but to explore the inner constructions and rhythms of form and thereby to attempt to reveal the underlying structure of the natural world. One of the more elusive features of nature for photographers, as much as for painters, was water. As in many photographs of the time, due to the long exposure, the water in Turner's image has turned into a veil wrapped around the forms of the rocks. Perhaps Turner tackled the subject in response to comments like the one made by a critic in 1853: 'It is worthy of note as relating to the existing practice of photography that quickly running and ruffled water … has not in any case been depicted with satisfactory results.'[71] Even in 1857 the subject still posed a problem for some photographers: 'Water our art altogether misses, turning it either into congealed mud or to mere chaos or nonentity'.[72]

It has been pointed out that Turner's river image 'is a good instance, perhaps, of purely *photographic* effect here used to good aesthetic effect'.[73] Perhaps Turner acknowledged and enjoyed this peculiar photographic phenomenon for its own qualities. Yet the difficulty of capturing moving water with anything like the veracity with which it is perceived by the human eye remained to be addressed by others like John Dillwyn Llewelyn (1810-82) and the undisputed master of the seascape, Gustave Le Gray. Their successes were highly praised. Given that Turner's project often seems to be essentially about the variety of quintessentially English scenery, it is surprising that fewer views of the island's coastline survive than one might expect. Some of the

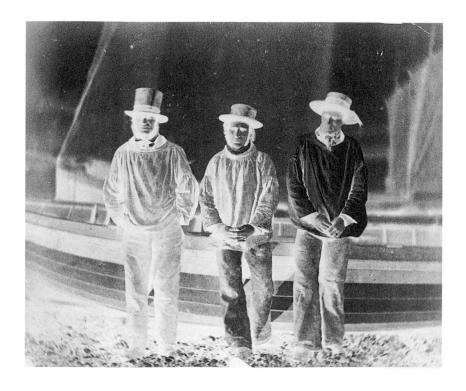

Fig. 36 B.B. Turner
Three Fishermen c. 1849
Calotype negative, waxed
6 1/8 × 7 1/4 in (15.6 × 18.5 cm)
Private collection, on loan to the V&A

rare examples, which are known only as negatives, are from the opposite side of the Devon coast from Lynmouth at Torquay: Ansty's Cove (pl. 35) and an eroded cliff known locally as 'London Bridge' (pl. 36). The holiday resort lies in a sheltered bay famed for its cliff-top walks and rocky coves. Turner's views of the coastline feature the compact layers of rock strata and dynamic geological oddities jutting into the sea. Added interest in such rock formations was given by Sir Charles Lyell's revolutionary theories outlined in *The Principles of Geology*, which first appeared 1830 and was revised and reprinted many times throughout the nineteenth century. His analysis of the various layers of rock, and the fossils they contained, allowed calculations to be made for the age of the planet that massively predated those previously estimated by counting back through biblical generations. Like Darwin, Lyell's studies brought attention to the position of humankind within the evolution of the earth and sharpened awareness of the passing of time.

Some negatives made with Turner's smaller camera – and hence indicating what may have been an earlier outing to the coast – show what appear to be fishermen dressed in smocks and wide brimmed hats posing by boats (fig. 36). These studies are

reminiscent of David Octavious Hill and Robert Adamson's pictures of Newhaven fisherfolk made in Scotland between 1843 and 1847. Studies of fisherfolk allowed early photographers to suggest the sea without actually having to embark upon the impossible task of taking views on the water in a pitching boat. In the mid-nineteenth century, against a background of political and social reform, pictures of seafaring people appeared to represent the settling ideal of an independent community of moral standing. Such images also hinted at British naval superiority in a period when the engineer Isambard Kingdom Brunel was creating the largest steam ships in the world.

Pathways, pilgrimages and farms in Kent and Surrey

Turner's photographic excursions to well-known sites were balanced by trips to less predictable, but equally rewarding corners of England. One of the reasons for his visits to less auspicious places, like Bredicot, was family connections. Turner's younger brother, William Frederick, is said to have 'learnt something about farming in a desultory and gentlemanly way' and that 'his intention of farming led him to live with farming friends, first in Kent, and afterwards in Suffolk'.[74] Apart from its proximity to London, this might have been the occasion for Turner's visit to the village of Hawkhurst, Kent, and the surrounding area.

Turner's *Farmyard, Elfords, Hawkhurst* (pl. 26) is the image which is perhaps the most reminiscent of Talbot's work. The bare branches of the elm trees and the dark clusters of rooks' nests show up clearly against the pale sky. Turner often worked on his negatives with pencil or ink to block out areas that he wanted to print lighter. The bright and completely featureless sky in the lane at Bredicot (pl. 5) is the result of inking out on the negative. In *Farmyard, Elfords, Hawkhurst*, however, the lace-like pattern of the trees that fills the sky would have been too complex to paint around and the effective lighter background has been achieved purely in the exposure. A water cart, haystack and ladder stand to the right. The stack has been cut back and some of the straw piled up as feed for the animals that would have been housed in the barn and fenced enclosure on the left. These events indicate the cycle of the rural calendar. The humble, but emphatically placed farm implements may simply be an accepted part of the standard repertoire of objects to be found within the naturalistic tradition of the English watercolour. However, it has been suggested by Mike Weaver

that this tradition is itself derived from Dutch and Italian painting, which imbued such objects with emblematic meaning.[75] Whether Turner consciously or unconsciously re-used similar visual elements from Talbot, and hence from what has been seen as a long iconographic tradition, is open to debate. Other images taken in the same area can also accommodate deeper readings. As Mark Haworth-Booth points out in his biographical essay here, *Hawkhurst Church, Kent* (or *A Photographic Truth*) can be understood as a comment on the self-reflexive nature and philosophical possibilities of photography (pl. 28).[76] Given that the subject reflected so perfectly in the still pond is a house of God, the image can also be read as a meditation on the nature of divine truth and its reflection in the physical world. Turner's full negative shows how much more symmetrical the reflection was before the bottom of the image was cropped closer to the church tower in the final print (pls 27 and 28). The cropping has the effect of flattening and abstracting the image so that it is less likely to appear as if it were afloat in pictorial space. Perhaps he considered the fuller reflection of the fourteenth-century church – with its fifteenth-century tower – to be too disorientating for his viewers, whom he might have felt needed a more anchored point of entry into the picture.

Looking further at Turner's negatives and comparing them with the final prints reveals not only how he subtly cropped the prints, as in *A Photographic Truth*, or moved objects, as at *Windmill, Kempsey, Worcestershire*, but also how he tested out the subject by approaching it from a variety of angles. Three negatives of *The Willowsway, Elfords, Hawkhurst* show different aspects of the same lane of pollarded willows with a pond to one side and a closed gate (figs 37, 38 and 39). Turner's son recalled how, even in his father's skilled hands, making one exposure 'never took less than three quarters of an hour'.[77] Turner probably spent about two and a quarter hours here. His final choice of image places the viewer on the path, framed with willows either side, as a traveller approaching the gate (pl. 23). Turner's familiar motif of the rural lane appears dramatically in his most frequently exhibited photograph, *Scotch Firs, Hawkhurst* (pl. 24). The fence sweeping diagonally to the right is made partly of wood but also of wire – an unusual modern note. But the rest of the scene shows familiar Turner subjects, the ancient trees, the reflection in a pond, the old farm buildings and a cartwheel.

Surrey to the south-west of London might also have taken, like the Kent series, an excursion of a day or two. The 10 Surrey views in *Photographic Views from Nature* were

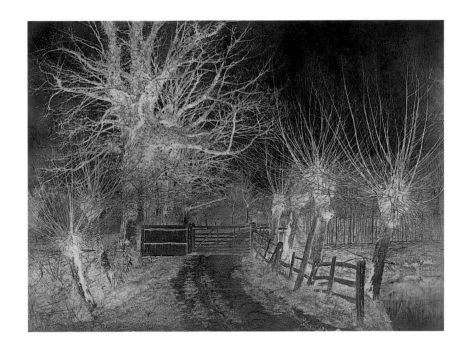

Fig. 37 B.B. Turner

The Willowsway, Elfords, Hawkhurst, 1852-4

Calotype negative, waxed

11 $^{11}/_{16}$ × 15 $^{13}/_{16}$ in (29.7 × 40.1 cm)

The Royal Photographic Society, Bath, England

17901

taken around wintertime and are all locations in close proximity. They are either on or near the 1,400-acre estate of Loseley House, just south of Guildford, about 30 miles (48 km) from the capital. Loseley House was built specifically to entertain Queen Elizabeth I in 1562-8. Most of the building stone came from the ruins of nearby Waverley Abbey, a casualty of the Reformation. Turner was fond of photographing the residences of the aristocracy. This shared tendency of the early amateur photographers – who were often from an upper middle-class professional background – has been interpreted as a desire to aspire to or share in a more aristocratic condition or lifestyle.[78] Turner's pictures of the house and grounds at Loseley follow the formal vistas of an approaching visitor: the long avenue of lime trees leading up to the house, the front of the house itself, the nearby entrance gateway (pl. 37) and the park and its lake (pl. 38).[79] The entrance gateway, with its geometrical shapes such as the triangular gables – one incorporating a dovecote – and the arch have long since vanished, although the separate bothy to the right and the entrance bridge still stand. Continuing through this gateway and past the house the visitor eventually finds him or herself at the head of the lake.[80] Cropped at top and bottom the tree on the right acts as a framing device with one long, dark branch cutting diagonally across the top of the picture like a bolt of lightning (pl. 38).

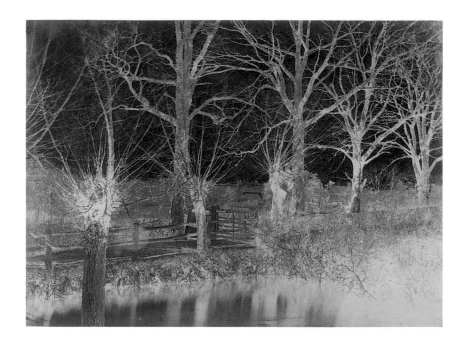

Fig. 38 B.B. Turner

The Willowsway, Elfords, Hawkhurst, 1852-4

Calotype negative, waxed

11 $^{11}/_{16}$ × 15 $^{13}/_{16}$ in (29.7 × 40.1 cm)

The Royal Photographic Society, Bath, England

17902

Turner continued his perambulations in the area at Hurtmore, photographing a country lane cutting between a house and a simple shed housing what appears to be low farm wagons (pl. 33). The composition is almost of two distinct halves with the lane curving tantalisingly off into shadow at the left, begging the eye to continue the journey, while past the gate and the shed at the right the land rises into a high embankment, defying the expectation of a low horizon. The same high horizon is used to good effect in a closer view of the shed which presents more of the tangle of pollarded branches on the left and a small pair of wheels placed curiously in the foreground (pl. 34). An alternative negative of this view, in the collection of the Royal Photographic Society (17949), reveals one minor difference: the wheels have been replaced by a bundle of sticks showing again how, as at Kempsey Windmill, Turner was not averse to tinkering with foreground details to enhance meaning or improve the composition and the apparently natural evidence of rustic disorder.

The nearby Eashing Bridge is a mediaeval double bridge spanning the river Wey. It is the best of a series of bridges on the river between Farnham and Guildford, which were probably built by the monks of nearby Waverley Abbey in the thirteenth century. Turner's view shows the rise of the bridge where it springs just before the riverbank (pl. 30). Although part of the reason for photographing this site must have

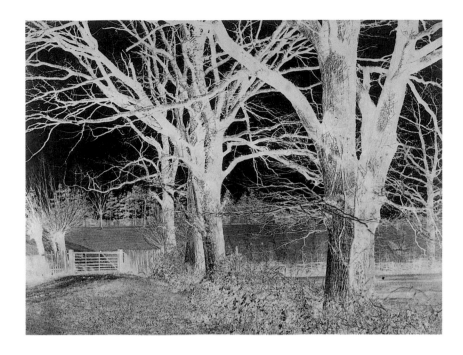

Fig. 39 B.B. Turner

The Willowsway, Elfords, Hawkhurst, 1852-4

Calotype negative, waxed

$11^{11}/_{16} \times 15^{13}/_{16}$ in (29.7 × 40.1 cm)

The Royal Photographic Society, Bath, England

17903

been its historical renown, Turner showed that his interest was not entirely on the structure but on its context, specifically the intricate patterns of the screen of trees. This is one of Turner's most deliberately two-dimensional pictures where the interest is held by the flat patterning filling the frame. Dark, dendritic patterns formed against pale skies on photographic paper were especially appealing to Turner and his fellow calotype practitioners. Trees were a subject that could demonstrate the camera's unparalleled veracity in recording natural forms. They were also often venerable subjects with long histories and nationalistic associations.[81] Less than half a mile from Eashing Bridge, in Peper Harow Park, through which the river Wey runs, Turner focused on a hoary oak tree producing something more akin to a portrait (pl. 31).

After passing through Peper Harow Park (spelt 'Pepperharrow' by Turner) the river Wey meanders towards Waverley Abbey, a site of pilgrimage, which is situated on the riverbanks. The village of Compton, just north of Eashing Bridge and Peper Harow Park, lay on the path of a well-known pilgrimage route. In the Middle Ages pilgrims would need to find overnight shelter in the area. Turner's view of a farmyard at Compton reveals one such location of refuge (pl. 32). The great barn, with its vast double doors thrown open, is most likely to have been built not primarily as an agri-

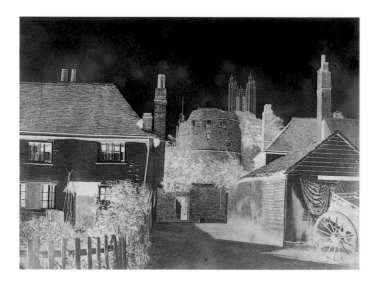

Fig. 40 B.B. Turner
Bell Harry Tower, Canterbury Cathedral, and St Augustine's Abbey,
c. 1859
Calotype negative, waxed
11^{11}/$_{16}$ × 15^{13}/$_{16}$ in (29.7 × 40.1 cm)
The Royal Photographic Society, Bath, England
17766

cultural building but as a pilgrim shelter.[82] Most barns of this period have a central passage served by two pairs of double doors in opposite walls. This standardised pattern allowed wagons to come into the barn through one door, unload crops and leave by the other door. Later, grain thrashed from the sheaves was winnowed by being tossed in a through-draught created by pinning open both sets of double doors.[83] Significantly, in the great barn at Compton there is no evidence of a second set of double doors on the other side of the building, where the roof slopes almost to the ground. Aside from its original unusual purpose, of which Turner may or may not have been aware, in the photograph the barn acts as a central point of focus in a detailed contemporary farmyard scene. In the foreground, a felled tree trunk and tangle of branches, probably stacked for use as firewood, lead the eye into the picture. On the left, a large corn rick, indicative of the summer's good harvest, stands raised on 'staddle' stones to protect it from damp, rats and mice. It has been thatched to preserve it until the harvested cereal is ready to be thrashed. Behind this a wooden thatched barn with combined dovecote has a pair of ladders, to climb corn and hayricks, conveniently hanging horizontally on its side. Next to the barn, propped up against the fence, stands a 'wattle hurdle', a movable gate woven from hazel twigs used to pen animals. On the right is a haystack used in part for the livestock's winter feed. As hay is less valuable than the precious corn stack on the left, the farmer has not taken the same care to raise it on staddle stones. Not a single sign of the nineteenth century intrudes. This ordered scene of abundance documents forms of age-old rural practice that were to vanish over the next few decades.

Meditations on the old and the new

Certain kinds of evidence of the contemporary seem not to have bothered Turner. In fact he used them positively to add interest to his compositions. Scaffolding, as seen in one of his Amsterdam views, was a particular favourite. The structural grid that it gave to a scene appealed to him, as in his close-up *Canterbury Cathedral* (pl. 40). He made a number of views of Canterbury, many of which were shown at the Photographic Society exhibitions in Glasgow and London in 1859. These show the cathedral close up and in the distance as part of the cityscape (fig. 40). Perhaps the cart on the right was the one that Turner had used to transport his equipment around the country. Its angle and fortuitous placing at the very edge of the image,

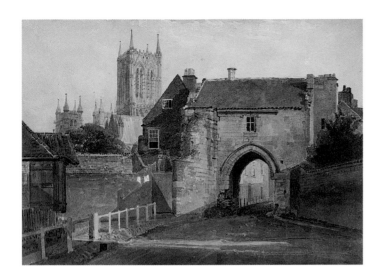

Fig. 41 Peter De Wint

Potter Gate, Lincoln, 1840s

Watercolour

11$^7/_{16}$ × 15$^5/_8$ in (29 × 39.7 cm)

V&A

P.59-1921

which directs the eye back into the picture, perhaps suggests Turner's familiar method of moving into shot elements that would be helpful to the composition. This cityscape is reminiscent of Peter De Wint's watercolour *Potter Gate, Lincoln* (fig. 41), which emphasises the foreground with its city portal (as Turner had done in *Gateway, Cathedral Yard, Peterborough*, pl. 13), leading the eye through and out of the shadowed street, over rooftops and chimneys to the majestic Gothic tower beyond. De Wint, with an almost photographic eye, also picked out less glamorous details like the unkempt road and bright bill posters on the wall, which lend an air of spontaneity to the scene. Turner consciously went further to record evidence of the modern in the cathedral town. In his close-up (pl. 40) he could easily have chosen a different view-point to exclude the metal pipes and ladders clustered around the buttress on the right. With an artist's sensibility for strong sensory contrasts and the picturesque, he chose instead to make a point of juxtaposing the flowing tracery in the Gothic window with the geometrical grid of the foreground railings and scaffolding.

It was perhaps Turner's interest in the underlying structures of natural and architectural forms that put him at ease when he made his remarkable photographs of what was the greatest iron and glass structure in the world, Joseph Paxton's Crystal Palace (pls 1 and 2). At first glance the images seem unlike anything else in Turner's oeuvre. At a rural retreat like Bredicot it would have seemed inappropriate to record evidence of the modern world but at the Crystal Palace the structure and the occasion demanded to be noticed, and Turner responded accordingly. Certainly when he photographed the structure it was the most modern and topical subject he could have chosen. Considered alongside all the attempts to show a nostalgic view of England in much of his other work, these images proclaim the undeniable stamp of his contemporaneity. Perhaps Turner enjoyed the unusual capacity of the glass structure to permit enough illumination for him to photograph from the inside of a building in full natural light. The same 'inside-out' phenomenon might have appealed to him in the roofless ruins of Whitby Abbey. Turner's view of the Crystal Palace transept contrasts the trunk and branches of the elm tree it housed with the ironwork columns and supporting struts of the building. Like the images of ruins it can be read as a comparative study on the work of nature and the engineering of man.

Yet little prepares us in the rest of Turner's work for his view of the 1, 848 feet (564 m) long nave (pl. 2). No doubt he was struck by the purity of its form after all the

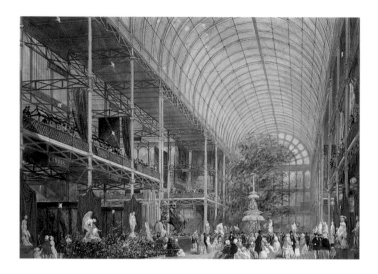

Fig. 42 Joseph Nash
Opening of the Great Exhibition of 1851, 1858
Watercolour
21 × 29¹/₁₆ in (53.4 × 73.8 cm)
V&A
73-1903

complex, historicising decoration of the exhibition courts, the objects and festive trappings had gone (fig. 42). While Turner had ignored the converging lines of railway track at Bredicot, here he showed another modern perspectival set-piece heralding a modern world with conviction. In this photograph he stripped to the bones the crucial elements of picture making in the western tradition. The building's structural lines are reminiscent of the draughtsman's grid used to work out perspective as prescribed by Alberti in the fifteenth century. But the perspectival grid is only the matrix for the underlying subject of this picture, which suggests what is at the heart of all Turner's artistic undertakings. Like his great namesake, Turner understood that light was the raw material of the artist. The photographer needs to be especially attuned to its intensities and variety and its effect on how we perceive that which it falls upon. Science melded light directly to art through photography in the 1850s. It was a period marked by rapid technical developments in the new medium. The educated and enthusiastic practitioners of this decade strove to develop technically and aesthetically an art they believed to be in its infancy. With the benefit of over 150 years of photographic practice we can now see that some of the work produced with pioneers' zeal had already reached a level of maturity that has often not been matched since.

By the time of Turner's death in 1894 he had set out many times to explore what the English landscape meant to him on the bright days he preferred. Throughout *Photographic Views from Nature* he demonstrated a fascination with English landscape and architectural types that represent the cross-section of English history favoured by a Victorian audience. His pictures can be read as a kind of compendium of patriotic and Romantic locations. Turner also demonstrated the variety of visual effects of which photography was capable. He relied on examples of past artists to give him a legitimate direction, but he also knew that he was dealing with a wholly new method of pictorial execution. Talbot had drawn attention to the fact that:

One advantage of the Photographic Art will be, that it will enable us to introduce into our pictures a multitude of minute details which add to the truth and reality of the representation, but which no artist would take the trouble to copy faithfully from nature. Contenting himself with a general effect, he would probably deem it beneath his genius to copy every accident of light and shade; nor could he do so indeed, without a disproportionate expenditure of time and trouble…[84]

Although steeped in tradition, Turner forged a new kind of visual sensibility in which photography's capacity to record the fine textures of the natural world became a new force of expression. It gave meaning and structure to the visible, which in turn suggested a higher order. It is a static vision which nevertheless bristles with life.

In visiting some of the locations that Turner photographed I was prompted to wonder what triggered his creative impulse to stop at just that spot, perhaps unremarkable in its time, to spend the time setting up his camera to record a section of rocky stream, a farmer's field or a tangle of branches. Inspection of the photographs of those locations showed Turner's capacity to bring structure and meaning to a scene and to orchestrate 'a multitude of minute details' and 'every accident of light and shade' which 'no artist would take the trouble to copy' – but a truly innovative *photographic* artist would. While pushing a new machine to test its limits, he marshalled and understood many of the unique aspects of its character. A combination of the practical limitations of his cumbersome, slow technical equipment and his distinct and personal visual sensibility led him to concentrate upon selecting either an intricate web of natural forms or bold motifs from the most appropriate angle. These motifs can become points of focus for both a Ruskinian observation of the underlying structures of nature and a lyrical, Wordsworthian meditation with revelatory possibilities. Turner's best pictures remain clearly in the mind like a familiar after-image. They seem to have the half-grasped significance of a particularly vivid dream.

Notes

Introduction

1. The description is Roger Fenton's in his unsigned 'Introductory Remarks' to *A Catalogue of an Exhibition of Recent Specimens of Photography exhibited at the House of the Society of Arts…*, 5 (London, 1852), pp. 4-5.

2. *Exhibition of the Works of Industry of All Nations, 1851. Reports of the Juries …* (London, 1852), p. 277.

3. *Art Journal*, 1 September 1852, p. 270.

4. Frederic T. Lott: 'Collodion v. Paper. To the Editor of the Journal of the Photographic Society', *Journal of the Photographic Society*, 21 November 1854, pp. 73-4.

5. Fenton, *Catalogue*, op. cit., pp. 4-5.

6. *Reports of the Juries*, op. cit., p. 279.

7. One might also cite Platt Babbitt's views of Niagara Falls, but these were really prompted by and meant to show the tourists standing before the falls.

Benjamin Brecknell Turner: A Biography

1. This biography is a revised and expanded version of my essay first published in *British Photography in the Nineteenth Century: The Fine Art Tradition*, edited by Mike Weaver (Cambridge University Press, 1989). It is based on 'Benjamin Brecknell Turner (1815-1894): Notes by his great-granddaughter Muriel Agnes Arber', 1985. This is in turn based on an account of the Turner family by BBT's son Philip Dymcock Turner. Miss Arber kindly allowed me to quote from her memoir, a typescript of which is in the files of the Photography Collection, Department of Prints, Drawings and Paintings, Victoria and Albert Museum. I am also grateful to the late Professor Giles Robertson, Mrs John Carswell, George Carter, Brian Coe, Roy L. Flukinger (Harry Ransom Humanities Research Center, University of Texas, Austin), Dr John Hannavy, Dr Carolyn Bloore, Colin Harding (National Museum of Photography, Film and Television), Hans P. Kraus, Jr, Pamela Roberts (Royal Photographic Society), Professor Larry Schaaf, John Ward (National Museum of Science and Industry) and Dr Mike Weaver.

2. Professor Giles Robertson, letter to the author, 28 July 1977, V&A Photography Collection, B.B. Turner files.

3. Robert Samuel Turner began collecting books as a boy. His collection became one of the best of its day and included fine bindings and rare copies of English, Italian, Spanish and French literature and one of the finest copies of the first folio of Shakespeare. The year after his death in 1887 the collection was auctioned and fetched high prices. The sale, which took place over 11 days, was followed eagerly in *The Times*. See obituary of R.S. Turner, *The Athenaeum*, 3111, 11 June 1887, p.76.; *Bibliotheca Turneriana Catalogue of the Library of the Late Robert Samuel Turner Esq…*, Sotheby, Wilkinson and Hodge, 18 June 1888; 'The Turner Library Sale', *The Times*, 22, 23, 27 and 29 June 1888.

4. John Hemingway, 'Paper based on Memoirs of Agnes Turner', 1978, Photography Collection file, National Museum of Science and Industry (by courtesy of John Ward).

5. Private collection, on loan to the V&A.

6. *Photographic Journal*, 26 February 1895, p.159.

7. John Spiller, 'The Eye as a Camera Obscura', *Photographic News*, 23 December 1859, p. 181.

8. Hans P. Kraus, Jr, and Larry Schaaf, *The Pencil of Nature*, facsimile edition (New York, 1989), p. 76.

9. Ibid.

10. George Carter collection, Norwich, England.

11. These early negatives are in a London private collection; some are on loan to the V&A.

12. John Hemingway, 'Paper', op. cit.

13. *A Catalogue of an Exhibition of Recent Specimens of Photography exhibited at the House of the Society of Arts*, 'Introductory Remarks' (unsigned article by Roger Fenton), 5, London, Society of Arts, 1852.

14. Craig Owens, 'Photography *en abyme*', *October*, 5 (Summer 1978), pp. 73-88.

15. H.J.P. Arnold, *William Henry Fox Talbot* (London, Hutchinson Benham, 1977), p.117.

16. Robert Hunt, 'The Photographic Exhibition', *Journal of the Society of Arts* 1, 7 January 1853, pp. 78-9.

17. Two Bonchurch views by Turner are known; one appears in *The Photographic Album for the Year 1857: Being Contributions from Members of the Photographic Club*, in the Royal Photographic Society and other collections; the other is in a private collection of Turner prints on loan to the V&A.

18. See Turner's technical note to his photograph *Bredicot Court* (pl. 6 in this book) in *The Photographic Album for the Year 1855: Being Contributions from Members of the Photographic Club*, in the Royal Photographic Society and other collections.

19. 'Mr. B.B. Turner, the Treasurer and Honorary Secretary of the Photographic Exchange Club, has issued a very satisfactory address to its members. All expenses are paid, and some few copies of the second volume of the "Photographic Album" remain in his possession, which may be obtained on the payment of an Honorary Member's subscription of ten guineas', *Journal of the Photographic Society*, 21 September 1858, p. 20.

20. Philip D. Turner, 'A Brief Account of my Family', undated typescript (about 1935), p. 17. I am grateful to Helen Gray of the Royal Archives at Windsor Castle for checking the Royal Collections. There is no record or evidence of the print surviving in the current Royal Collections.

21. *The Sketch Book of Geoffrey Crayon, Gent.* (London, Artist's Edition, 1865), p.100.

22. 'On the Calotype Process', *Photographic News*, 1 October 1858, p.38.

23. 'Paper v. Collodion', *Photographic News*, 19 August 1859, pp. 279-80.

24. M. Haworth-Booth, 'Early Scottish Exhibitions', *History of Photography*, Autumn 1994, pp. 286-7.

25. Catalogue of the Photographic Society Exhibition, London 1859, nos 207 to 211.

26. Ibid.

27. After Turner's death, 245 paper negatives were given to the Royal Photographic Society in a wooden box. Inside the lid is inscribed the information that the box contains 'paper

negatives mostly 15″ × 12″ made by B.B. Turner for Murray & Heath about 1850-60'. The firm sold photographs by leading English and French photographers in the 1850s.

28. *Photographic Journal*, 15 May 1860, p. 243.

29. 'Photography and the Volunteers', *Photographic Journal*, 16 July 1860, pp. 269-71.

30. *Photographic News*, 21 April 1859, pp. 79-80.

31. See M. Haworth-Booth, *Photography: An Independent Art. Photographs from the Victoria and Albert Museum 1839-1996* (London and Princeton, V&A Publications and Princeton University Press, 1996), pp. 78-9.

32. Quoted by Muriel Arber (see note 1 above).

33. *British Journal of Photography*, 1 October 1875, p. 470. The carbon process is described in B. Coe and M. Haworth-Booth, *A Guide to Early Photographic Processes* (London, V&A Publications, 1983).

34. *Photographic Journal*, 10 October 1881, lists among the society's exhibits no. 181, *Burnham Beeches*, and no. 208, *Rivage Dinant on the Rhine*.

35. Examples are on loan to the V&A Photography Collection. Turner's will refers to a 'Book of photos of Risby' which may be by him; his brother William Frederick Turner lived at Risby Place, Risby, near Bury St Edmunds, Suffolk. The will also states that 'photos etc' were left to his son-in-law Henry Robert Robertson. The 'photos etc' included the album now in the V&A and another album, now in the Scottish Photography Archive, Scottish National Portrait Gallery, Edinburgh, which contains four photographs by Turner and others by David Octavius Hill and Robert Adamson. A summary of the will is in the V&A Photography Collection, Turner files.

Photographic Views from Nature

I am indebted to Mark Haworth-Booth whose essay 'Benjamin Brecknell Turner: Photographic Views from Nature, in *British Photography in the Nineteenth century: The Fine Art Tradition*', ed. Mike Weaver (Cambridge and New York, Cambridge University Press, 1989) forms much of the background for the present essay. He has also built up, over nearly 20 years, the voluminous Photography Section files on B.B. Turner at the V&A. I am also grateful to have had access to Christopher Titterington's previous work on the connections between watercolour artists and early photographers for his exhibition *The Pencil of Nature: Watercolour and the Invention of Photography* at the V&A in 1995. These resources and perceptive insights have been invaluable.

1. 'He used to take about with him his enormous camera, and a portable dark room; the whole fitting on to a two-wheeled go-cart', Philip D. Turner, 'A Brief Account of my Family', undated typescript (about 1935), p. 16. Philip D. Turner was B.B. Turner's son. A copy is held in the V&A Photography Collection file. I am grateful to Mrs Ianthe Carswell for allowing me to make a copy of this family history.

2. The gold tooling on the cover and the standard decorative border motifs were probably made with metal stamps used on many different types of bindings. The marbled end papers and printed title and contents pages would have been costly to produce as a 'one off' but do not indicate mass production. The binding does not contain a manufacturer's or publisher's label. Since its arrival in the V&A collection from Turner's descendants in a loosely bound state the album leaves with the photographs pasted on were separated from the binding. This has allowed the care and display of separate photographs in frames as Turner would have presented them in exhibitions. The original sequence of the photographs has been preserved in the museum numbering system and is evident from the title page. See Turner's contents page (fig. 21) for a full list of plates in *Photographic Views from Nature* in their original sequence. I am grateful to Pascale Regnault of the V&A Books

Conservation Department for discussing the album binding with me.

3. In several instances in *Photographic Views from Nature* it is evident that a slightly larger print of the same image has been pasted over the top of a smaller print. Occasionally the print beneath exhibits signs of damage, appearing to have been partly torn from the backing. This may have been because Turner was not satisfied with the quality of a particular print in comparison with others once he had assembled the album, that the original print had faded or that he had subsequently preferred a less tightly trimmed version of the image.

4. Hans P. Kraus, Jr, and Larry Schaaf, *The Pencil of Nature*, facsimile edition (New York, Hans P. Kraus, Jr, 1989), p. 76.

5. Ibid. Talbot's introduction.

6. For an in-depth examination of proto-photographic art and ideas surrounding the genesis of photography, see Peter Galassi, *Before Photography: Painting and the Invention of Photography* (New York, Museum of Modern Art, 1981), and Geoffrey Batchen, *Burning with Desire: The Conception of Photography* (Cambridge, Mass., and London, MIT Press, 1997).

7. One of the central sources for the sets of both J.M.W. Turner and Constable prints can be traced back to the 17th-century Italian artist Claude Lorrain's *Liber Veritas* (c. 1635), a book of pen and ink sepia drawings made by the artist to record his paintings before they left the studio. The book was purchased and brought to Britain in the 1720s and from it a set of reproductions in etching and mezzotint was made. It was highly popular and inspired not only artists but also landscape gardeners who, in a significant case of life imitating art, shaped the English landscape by planting real trees and shrubs in an attempt to reproduce Claude's compositions. See Ronald Parkinson, *John Constable: The Man and his Art* (V&A Publications, 1998), pp. 117-28.

8. John Constable, introduction to *English Landscape: Various Subjects of Landscape Characteristic of English Scenery principally intended to Display the Phenomena of Chiar'oscuro of Nature: From Pictures*

painted by John Constable, RA, engraved by David Lucas (London, 2nd edition, 1833).

9. 'The Photographic Exhibition', *Journal of the Photographic Society*, 3, 21 January 1857, p. 193.

10. B.B. Turner, 'A Photographic Scrapbook', copy held in V&A Photography Collection file. This consists of clippings from photographic journals mainly on technical matters.

11. Grace Seiberling and Carolyn Bloore, *Amateurs: Photography and the Mid-Victorian Imagination* (Chicago and London, 1986), p. 47.

12. 'Exhibition of Recent Specimens of Photography', *Journal of the Society of Arts* 1, 24 December 1852, pp. 62-3.

13. For an in-depth examination of the depiction of rural conditions see Anne Bermingham, *Landscape and Ideology. The English Rustic Tradition, 1740-1860* (London, Thames and Hudson, 1987) and Christine Payne, *Toil and Plenty: Images of the Agricultural Landscape in England 1780-1890* (New Haven and London, Yale University Press, 1993).

14. William Cobbett, *Rural Rides* (1830, Penguin, 1985), p. 389.

15. 1851 Census Returns, Parish of Bredicot.

16. Copies of *The Photographic Album for the Year 1855* and *The Photographic Album for the Year 1857* are held at the Royal Photographic Society, Bath, England and the J. Paul Getty Museum, USA.

17. Copy of manuscript by Agnes Turner *née* Chamberlain. Photography Collection file, ex Science Museum Photography Collection archive (by courtesy of John Ward).

18. A negative in the collection of the Royal Photographic Society (17896) shows that Turner also photographed the dovecote equally successfully from a different angle later in the year when the trees were in leaf.

19. *Copy Award on the Inclosure of the Open and Common Arable Meadow and Pasture Lands and Fields in the Parish of Bredicot In the County of Worcestershire 1846*, Worcestershire Record Office.

20. The church of St James the Less is 13th century in origin but has 19th-century additions, probably instigated by the Chamberlain family.

21. Copy of manuscript by Agnes Turner *née* Chamberlain, op. cit.

22. Baldus's choice of subject was in part dictated by the commissions he received to photograph the railway line between Paris and Boulogne in 1855 and the Marseilles-Lyon line to Toulon in 1859. See Malcolm Daniel, *Edouard Baldus* (New York, Metropolitan Museum of Art, 1994).

23. I am grateful to the current residents of Bredicot Court, Mr and Mrs Robinson, for their keen observation of this photograph which positively located the exact spot where it was taken. The figure became indisputably recognisable as Turner after the negative was scanned into a computer, inverted into a positive image and enlarged.

24. I am grateful to Robin Hill of Worcestershire County Museum for discussing Turner's photographs with me and for his advice on rural implements and practices.

25. Around 80 portrait photographs by Turner of family and friends survive in a private collection. Some of these were made outdoors at Bredicot, but the majority appears to have been made in his glass-roofed studio over the premises of his business in London.

26. *The Victoria History of the Counties of England: Worcestershire* (University of London, 1971), p. 329.

27. Anon, *Ludlow Castle: A Guide* (1987), p. 5.

28. See Martin Barnes and Christopher Whitehead, 'The "Suggestiveness" of Roman Architecture: Henry Cole and Pietro Dovizielli's Photographic Survey of 1859', *Architectural History*, vol. 41 (1998), pp. 192-207.

29. Thomas Wright, *An Historical and Descriptive Sketch of Ludlow Castle and the Church of St. Lawrence, Ludlow* (Ludlow, 1848), p. 32.

30. Ibid. p. 42.

31. Ibid. p. 36.

32. Ibid. p. 42.

33. The format was often used to trim away areas with no image, which was a result of the lens not being able to cover fully the whole of the negative. In these areas, the image fell away, registering as light ellipses at the edges of negatives and printing as dark areas on positives.

34. As Seiberling and Bloore point out (see *Amateurs*, op. cit., p. 48) the *Illustrated London News* ran a regular feature during the late 1840s and early 1850s entitled 'Nooks and Corners of Old England' which highlighted antiquarian subjects. The subjects that it pictured were often described in relation to their state of preservation as well as to their aesthetic features and historical significance. Such concern anticipates the activities of the Society for the Protection of Ancient Buildings later in the century.

35. These signs can be found in Royal Photographic Society negatives *Cromer, from Norwich Road* (17813), *Severn End* (17877), *Christ Church Gate, Canterbury* (17777), and *Bell Harry Tower, Canterbury from St Augustine's* (17766).

36. After dissolution, Pershore Abbey was converted into a church. Today, like most English ruins, it is stripped of its ivy, and two large flying buttresses, constructed in 1913 to shore up the increasingly unstable tower, significantly alter its appearance from that in Turner's photograph.

37. Anon, *The Guide to Whitby and the Neighbourhood Comprehending a Description of the Abbey* (Whitby, 1850), p. 32.

38. Ibid. p. 1.

39. Ibid.

40. William Wordsworth, 'Lines composed a Few Miles above Tintern Abbey, on revisiting the Banks of the Wye during a Tour, July 13, 1798'.

41. John Martin Robinson, *Arundel Castle. A Seat of the Duke of Norfolk E.M.: A short history and guide* (Chichester, Philimore & Co. Ltd, 1994), p. 28.

42. Coade stone was an artificial cast stone manufactured by Eleanor Coade's firm in London from 1770s. The sculptor, Rossi, worked as a modeller of designs for the firm in the earlier part of his career. See Rupert Gunnis, *Dictionary of British Sculptors 1660-1851* (1951), p. 105.

43. John Claudius Loudon quoted in Martin Robinson, op. cit., p. 32.

44. Martin Robinson, op. cit., pp. 55-6. Visitors books were kept from June 1856. In 1857, 1,102 tourists were recorded.

45. Ibid., p.56. The royal couple stayed for three days in December 1846.

46. Ibid., p. 46. A new east wing was reconstructed 1877.

47. A windmill is recorded as having existed at Kempsey in 1299; *The Victoria History of the Counties of England: Worcestershire* (University of London, 1971), p. 433.

48. T.C. Turberville, *Worcestershire in the Nineteenth Century* (London, 1852), p. 210.

49. There were two windmills at Kempsey in 1821, but the last was pulled down about 1875. *The Victoria History of the Counties of England: Worcestershire*, op. cit., p. 433.

50. Timothy Wilcox (ed.), *The Romantic Windmill. The Windmill in British Art from Gainsborough to David Cox, 1750-1850* (Hove Museum and Art Gallery, 1993), p. 13.

51. See 'The Mill by Rembrandt', essay by Michael Pidgley in Wilcox (ed.), *The Romantic Windmill*, op. cit., p. 16-27. Rembrandt's painting *The Mill*, is dated *c.* 1650, oil on canvas, National Gallery of Art, Washington.

52. Three of the negatives of Kempsey Mill are at the Royal Photographic Society (nos 17868, 17869, 17870). The fourth is at the National Museum of Photography, Film and Television, Bradford (1886-10). I am grateful to Mark Haworth-Booth, Penny Martin and Brian Liddy for their assistance with the Kempsey Mill negatives.

53. This analysis is based on Mark Haworth-Booth's, 'B.B. Turner: Thoughts on Kempsey Mill' from Michael Hallett (ed.), *Rewriting Photographic History* (Conference Proceedings, Birmingham Polytechnic 1989, Article Press, 1990), pp. 9-10.

54. Turner's obituary, written by John Spiller in the *Photographic Journal*, 26 February 1895, p.159, notes his use of Wheatstone's reflecting stereoscope from around 1852 onwards.

55. I am grateful to John Ward, formerly of the Science Museum, London, for explaining this principle to me and for showing me examples of Wheatstone stereo viewers in the Science Museum collection. Photographs made for use in a Wheatstone viewer could be made with a normal camera although special cameras existed which incorporated a sliding base to fix the optimum distance from one exposure to the next. The more abundant, popular stereographs consisted of photographs made with a dual-lens camera and pasted next to each other on to a single sheet of card measuring about 3 1/2 × 6 7/10 in (9 × 17 cm) to be viewed through a stereoscope. Turner probably preferred the Wheatstone stereograph because it would have allowed him to use his normal camera and the larger print size (about 10 5/8 × 15 1/3 in (27 × 39 cm) more associated with 'fine art' subjects. For a discussion of the Wheatstone reflecting stereoscope and the nature of stereoscopic effect in general see: Jonathan Crary, *Techniques of the Observer: On vision and modernity in the nineteenth century* (Cambridge, Mass., and London, MIT Press, 1990), pp. 116-29.

56. The Wheatstone stereoscopic pair of photographs of Kempsey Windmill (1876-530) was presented by R. Sabine to the South Kensington Museum in 1876. The photographs were subsequently transferred to the Science Museum collections and hence to the National Museum of Photography, Film and Television, Bradford. One half of the Wheatsone pair corresponds with the print in *Photographic Views from Nature* (Royal Photographic Society negative 17868), the other with National Museum of Photography Film and Television negative 1886-10. I am grateful to Colin Harding and Brian Liddy of the National Museum of Photography, Film and Television, and Penny Martin for drawing my attention to this. For a paper negative by Turner that may be half of a Wheatstone stereo pair see Rainer Michael Manson *et al.*, *Pygmalion Photographe: La sculpture devant la camera 1844-1936* (Geneva, Cabinet des Estampes, Musée d'Art et d'Histoire, 1985), no. 31, 'Buste de Dionysus'.

57. '...his old oaks and cottages are far bolder than anything on collodion; broad shadows give a massive look to the trunks and architecture, and a stereoscopic effect which few, very few, collodion pictures have.' *Photographic News*, 19 August 1859, pp. 279-80.

58. Crary, *Techniques of the Observer*, op. cit., p. 126.

59. Of the 16 negatives for the Amsterdam views, 13 are in the collection of the Royal Photographic Society. Two more are held at the Gemeentearchief, Amsterdam. They were attributed to Turner by the Gemeentearchief's Curator of Photography, Anneke van Veen, after being offered for sale at Sotheby's, London, 9 May 1991, lots 13 and 14. The remaining negative is at the Harry Ransom Center, University of Texas, Austin. Eleven prints of Amsterdam are currently known to exist in public collections: eight are held at the Gemeentearchief, Amsterdam, two at the Rijksmuseum (Royal Antiquarian Society), Amsterdam, and one at the Canadian Centre for Architecture, Montreal.

60. Philip D. Turner, 'A Brief Account', op. cit., p.13.

61. The only other currently known photograph by Turner which has been positively identified as having been taken outside England and Amsterdam is a view of Bruges showing the Begijnhof in the foreground, V&A: E. 1208-2000. This print, possibly a carbon print (13 1/3 × 17 1/3 in; 34 × 44 cm), is attributed to Turner on the grounds that it is part of a group of his later work which was in the possession of the family. Turner's work on this scale, printed in carbon, probably dates from the 1870s or 1880s. The view could have been made on a later excursion to The Netherlands. I am grateful to Eloy Koldeweij of the Rijksdienst Voor De Monumentenzorg and Anneke van Veen of the Gemeentearchief, Amsterdam, for making the positive identification of the location of this photograph. Another carbon print likely to be by Turner (14 × 17 in; 36 × 43.5 cm) from a private collection on loan to the V&A shows three boys wearing jackets, shoes and hats that appear not to be English but are perhaps from The Netherlands, Low Countries or northern France.

62. Philip D. Turner, 'A Brief Account', op. cit., p.17.

63. See Mattie Boom, *Eduard Isaac Asser, 1809-1894* (Amsterdam, Focus, 1998) and Anneke van Veen, *Pieter Oosterhuis, 1816-1885* (Amsterdam, Gemeentearchief / Fragment, 1993). Asser made calotypes of the city while Oosterhuis used glass

plates and produced stereographs. A daguerreo-type of a canal house made in 1856 by Jan Adriaan van Eijk exists in a private collection.

64. I am grateful to Anneke van Veen and Erik Schmitz of the Gemeentearchief, Amsterdam, for their assistance with dating Turner's Amsterdam views.

65. The print is still in the possession of the Royal Antiquarian Society. Their offices and collections are now housed within the premises of the Rijksmuseum, Amsterdam.

66. *Catalogus der Tentoonstelling van Photographie en Heliographie, gehouden door de Vereeniging voor Volksvlijt, 1858*. The entry for the eight Amsterdam views by an English artist appear as catalogue no. 4 under the exhibitor's name, W.H. Kirberger. Kirberger was a bookseller in Amsterdam through whom Turner may have sold his prints. See Mattie Boom, 'Een geschiedenis van het gebruik en verzamelen van foto's in de negentiende eeuw' in J.F. Heijbroek and R. Meyer (eds), *Voor Nederland bewaard. De verzamelingen van het Koninklijk Oudheidkundig Genootschap in het Rijksmuseum*, Baarn, 1995, pp. 273-94. I am grateful to Mattie Boom of the Rijksmuseum and Anneke van Veen of the Gemeentearchief, Amsterdam, for their generous help and advice on Turner's Amsterdam photographs.

67. Photographic Society of London 1858, exhibit nos 386, 489, 498 and 668.

68. From Wordsworth's letters, November 1797, and Edward Dowden, *The Life of Percy Bysshe Shelley* (1886) quoted in John Travis, *An Illustrated History of Lynton and Lynmouth 1770-1924* (Derby, 1995), p. 16.

69. The name 'Lyndale' does not exist in current British atlases although it could be a 19th-century local name from North Devon. Turner might have meant nearby Lynton.

70. *John Ruskin at Glenfinlas*, 1854, oil on canvas, private collection, illustrated in Peter Funnell, Malcolm Warner *et al.*, *Millais: Portraits* (London, National Portrait Gallery, 1999), pp. 63, 91.

71. James Glaisher, 'On the Chief Points of Excellence in the Different Processes of Photography as Illustrated by the Present

Exhibition', *Journal of the Society of Arts*, 1, 28 January 1853, p. 110.

72. 'The Photographic Exhibition', *Journal of the Photographic Society*, 3, 21 January 1857, p. 193.

73. Mark Haworth-Booth, 'Benjamin Brecknell Turner: Photographic Views from Nature' in Mike Weaver (ed.), *British Photography*, op. cit., p. 84.

74. Philip D. Turner, 'A Brief Account', op. cit., p. 21.

75. The suggestion is that a form of iconography related to occult philosophy or Christian tradition lies behind Talbot's images, which do not accidentally combine cartwheels, ladders and haystacks. According to this reading the cartwheel can be understood as a type of St Catherine's wheel, an instrument of torture, impeding those who struggle to climb the ladder – a symbol of spiritual aspiration. 'The ladder becomes a Jacob's ladder extending heavenward … In the context of a haystack it may represent the only means by which man can resist his fate – "all flesh is hay" '; Mike Weaver, *The Photographic Art: Pictorial Traditions in Britain and America* (Edinburgh, Scottish Arts Council, 1986), p. 13.

76. Turner used the title 'A Photographic Truth' when he inscribed the envelope in which he kept the negative, now at the Royal Photographic Society. Philip D. Turner's 'A Brief Account', p. 17, also notes the alternative title '"A Photographic Truth" (the view of Hawkhurst Church with its reflection in a pond)'.

77. Philip D. Turner, 'A Brief Account', op. cit., p. 16.

78. See Seiberling and Bloore, *Amateurs*, op. cit., pp. 54-5.

79. Other grand aristocratic residences photographed by Turner include Arundel Castle in Sussex and Castle Howard in Yorkshire.

80. I am grateful to the guides of Loseley House and Michael More-Molyneux, the current owner, for his enthusiasm to follow in Turner's footsteps and his kindness in showing me the estate.

81. Mid-19th-century books on trees, such as *Sylva Brittanica: or Portraits of Forest Trees Distinguished for their Antiquity, Magnitude or Beauty, drawn from

Nature and Etched by Jacob George Strutt* (London, 1826) or J.C. Loudon's scholarly and extensive *Arboretum et Fruticetum Britannicum* (1842), associated trees with history, art, literature and the gentry. On the subject of trees for early amateur photographers see Seiberling with Blore, *Amateurs*, op. cit., pp. 57-9. The interest in botany at this time is reflected in the construction of many public arboretums. J.C. Loudon was responsible for the design of the arboretum at Derby.

82. The barn is located at Coney Croft farm, a short walk down the lane from the artist G.F. Watts' memorial chapel at Compton. Cecilia Lady Boston's *The History of Compton in Surrey* (London, 1933), p. 51, states:

In the case of the great barn at Coney Croft Farm, where the entire structure is of wood without brick walling, an even earlier date [than the early 16th century] before the brick making industry had become established, is possibly indicated. The fact that the farm house of Coney Croft is of modern construction and that no previous building of the same character seems to have occupied its site, lends support to a suggestion recently made to the effect that 'Coney-but Barn' ['Coney-but barn' in early parish registers] was originally erected for other than agricultural purposes, and may be classed among the 'Pilgrim barns', or shelters, erected for wayfarers, which have been identified in various other places along well-known pilgrimage routes. An inspection of this barn and its site will reveal the fact that it stands upon a triangle of ground formed by three ancient foot or bridle tracks, and is well below the level of much of the present roadway.

The barn has recently been partly clad in stone at the lower level. I am grateful to Mr and Mrs Buchanan, the current owners of Coney Croft Farm, for allowing me to inspect their barn and for pointing out the reference to it in *The History of Compton*.

83. See Nigel Harvey, *Old Farm Buildings* (Shire Publications, 1997), p. 5.

84. William Henry Fox Talbot, commentary to plate X, *The Haystack*, in *The Pencil of Nature* (1844), Kraus, Jr, and Schaaf, *The Pencil of Nature*, op. cit.

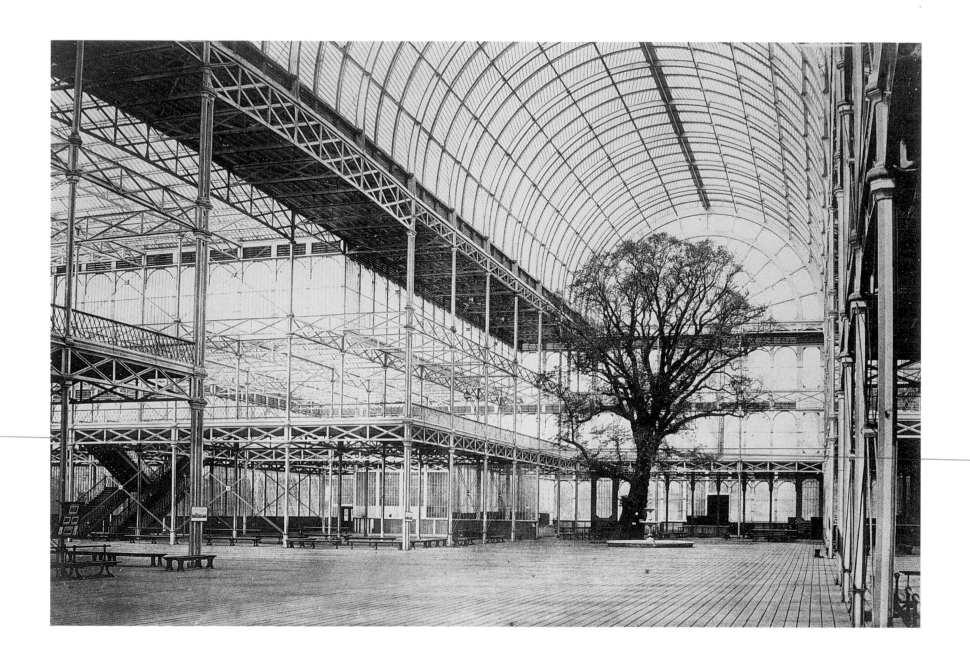

1 *Crystal Palace, Hyde Park, 1852, Transept*

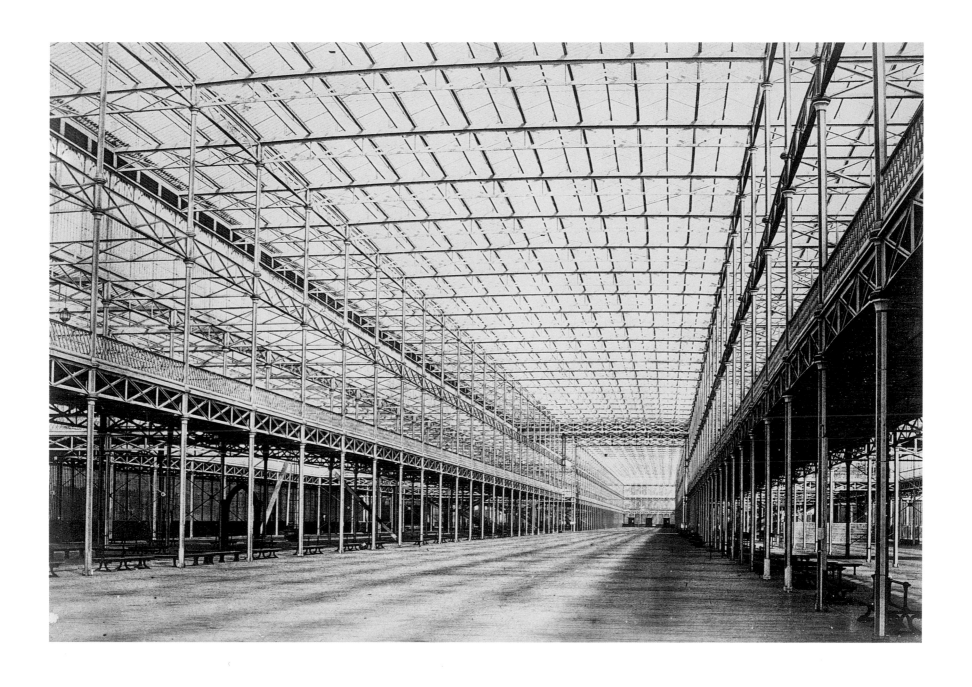

2 *Crystal Palace, Hyde Park, 1852, Nave*

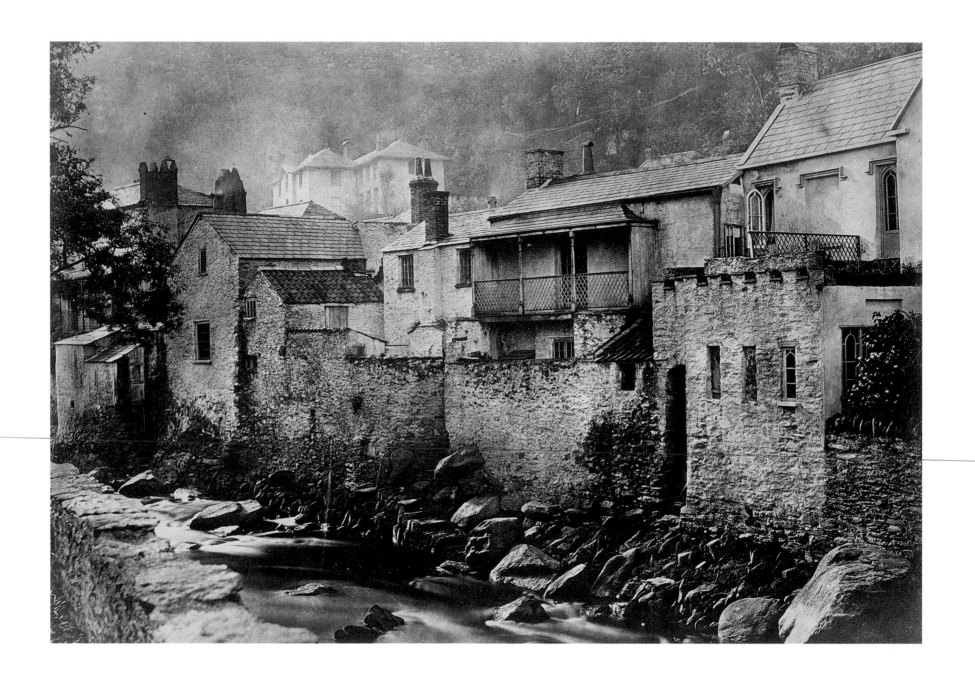

3 *Lynmouth, North Devon*

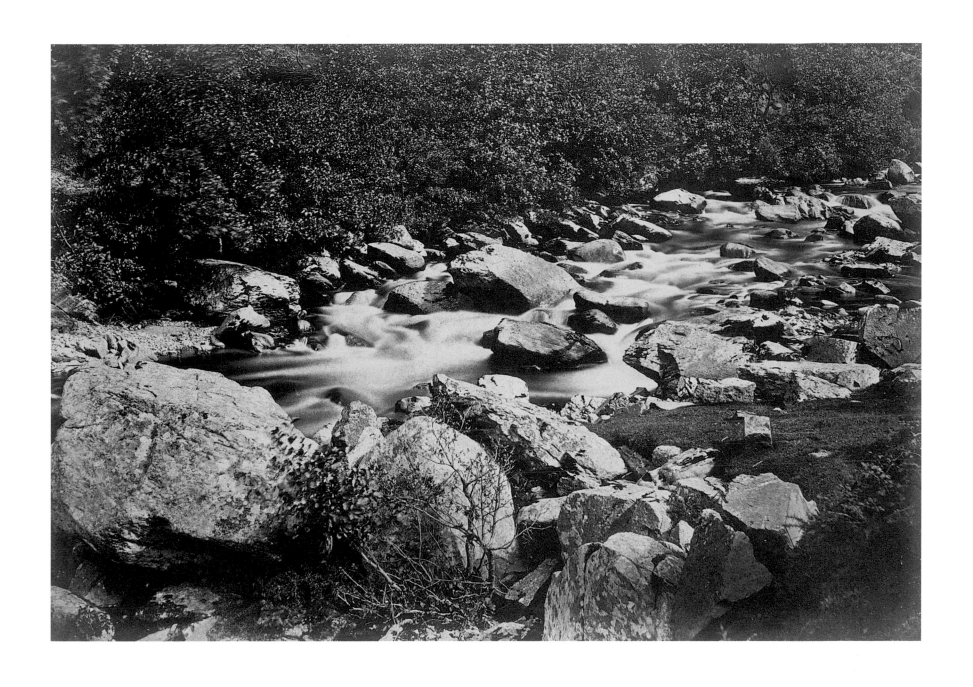

4 *Lyndale, North Devon*

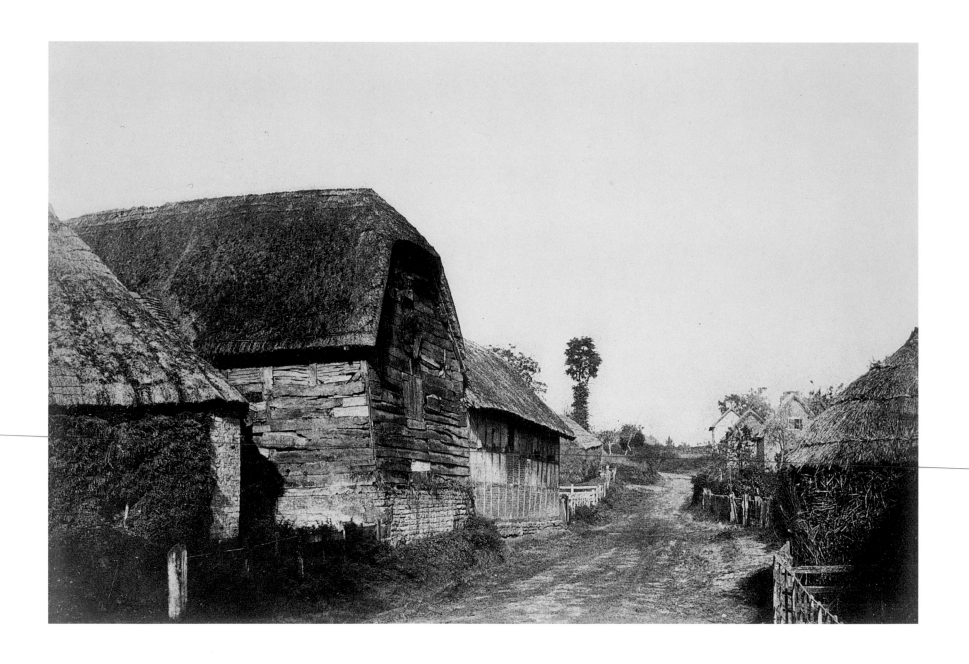

5 *Bredicot, Worcestershire*

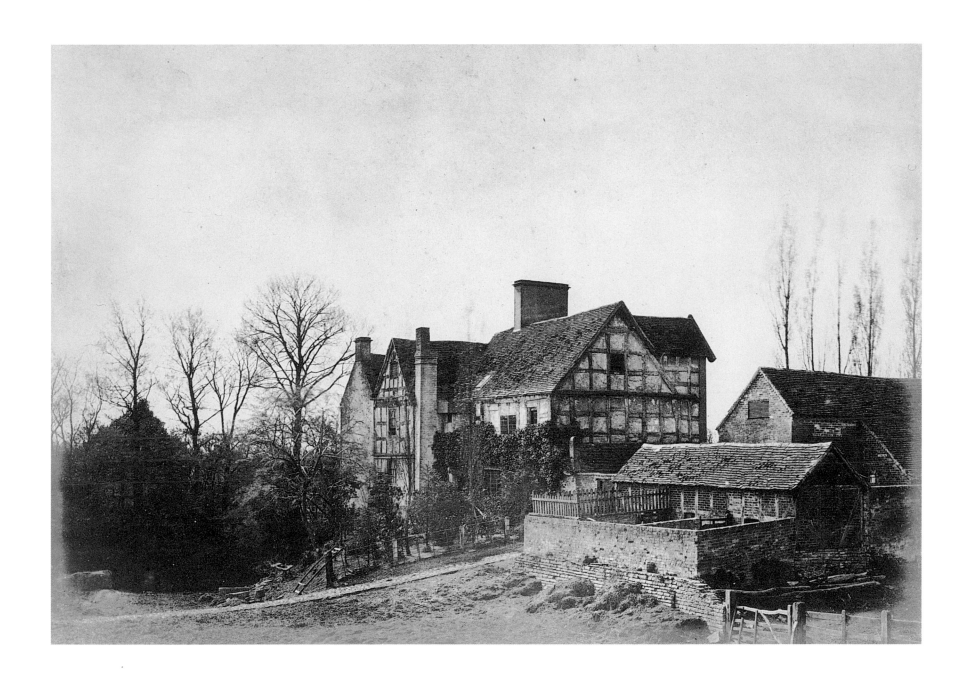

6 Bredicot Court, Worcestershire

7 *Bredicot, Worcestershire*

8 *Foldyard, Bredicot Court, Worcestershire*

9 *Bredicot, Worcestershire*

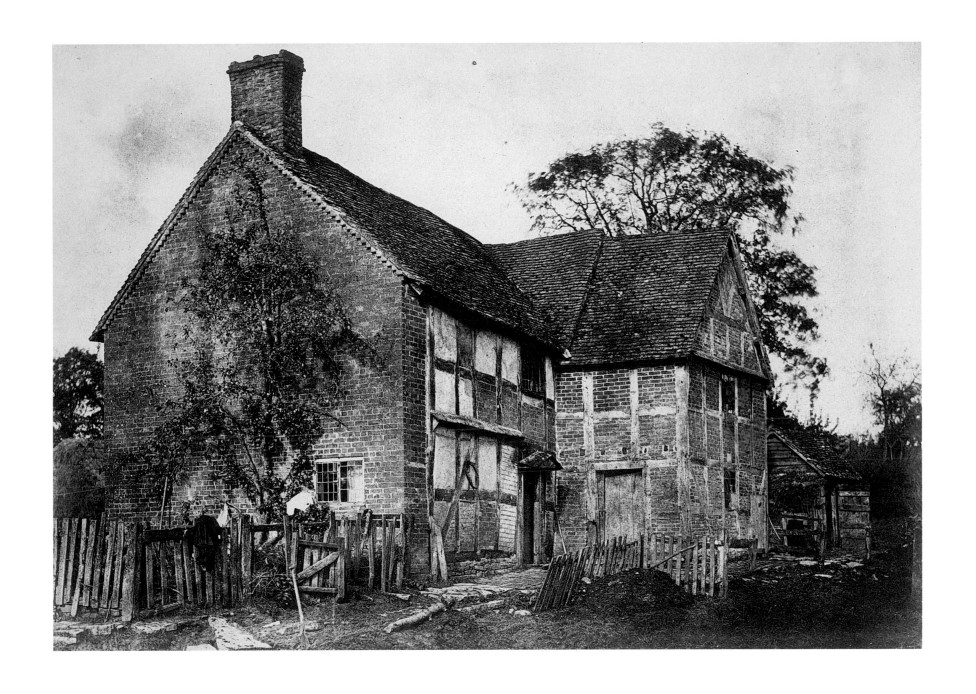

10 *Bredicot, Worcestershire*

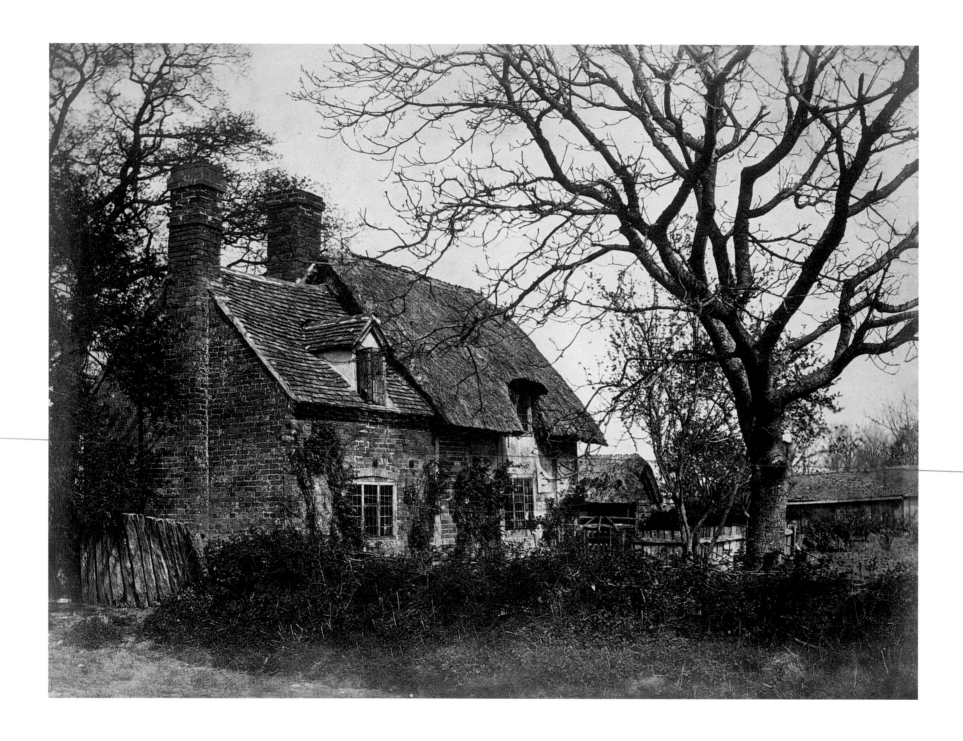

11 *Cottage, Bredicot Common, Worcestershire*

12 *Crowle Court, Worcestershire*

13 *Gateway, Cathedral Yard, Peterborough*

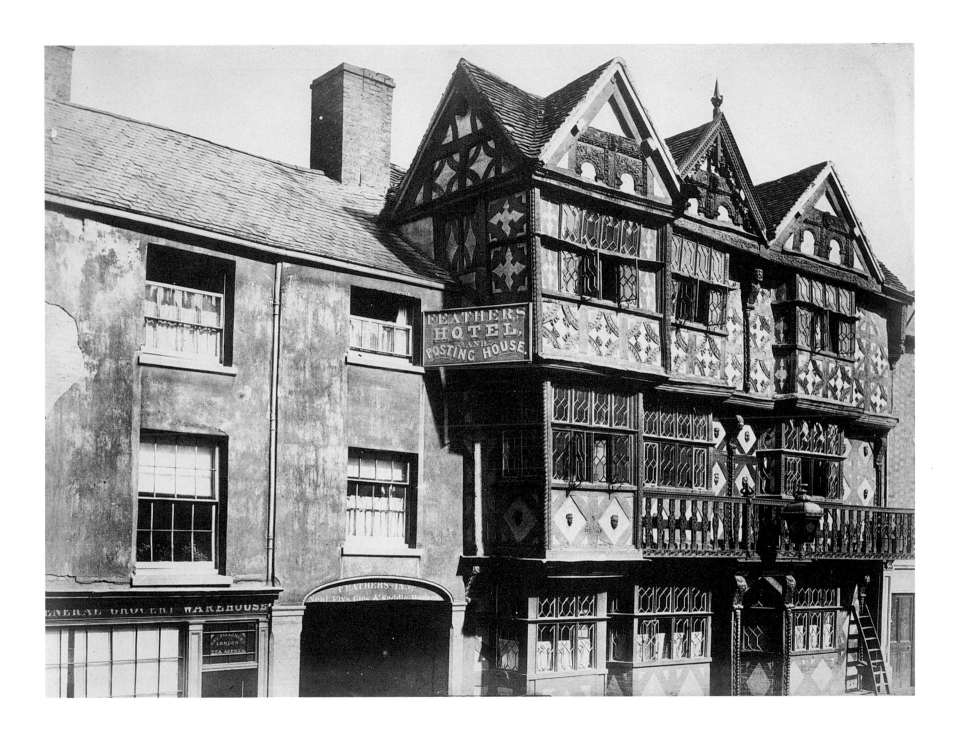

14 *Ludlow*

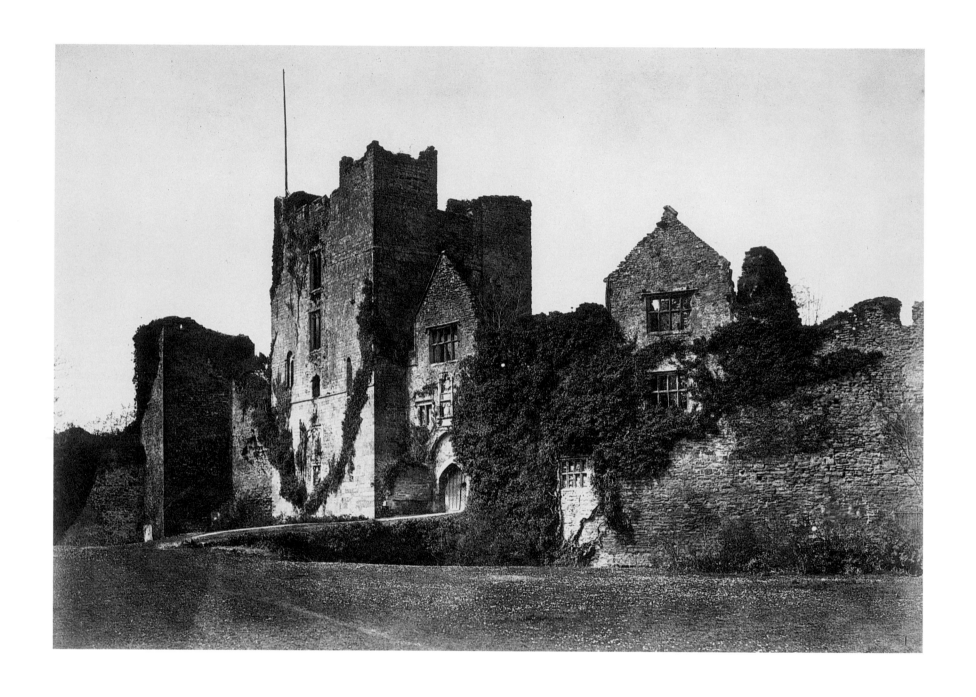

15 *Ludlow Castle, from the Tiltyard*

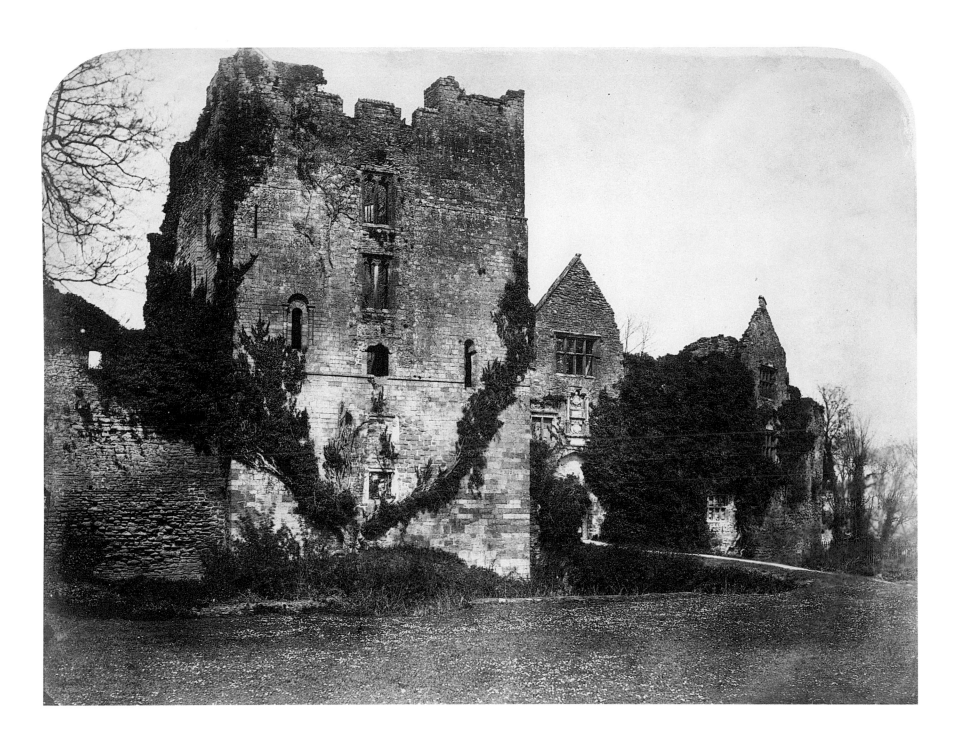

16 *Ludlow Castle, from the Tiltyard*

17 *Ludlow Castle, Causeway and Entrance*

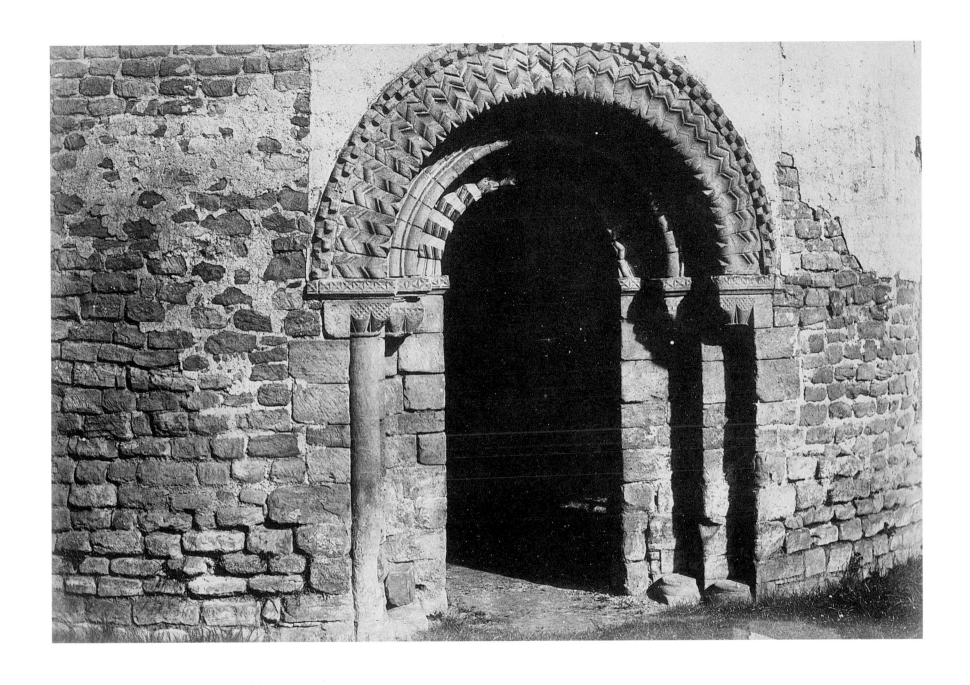

18 *Ludlow Castle, Doorway of Round Church*

19 *Abbey Church, Pershore, Worcestershire*

20 Windmill, Kempsey, Worcestershire

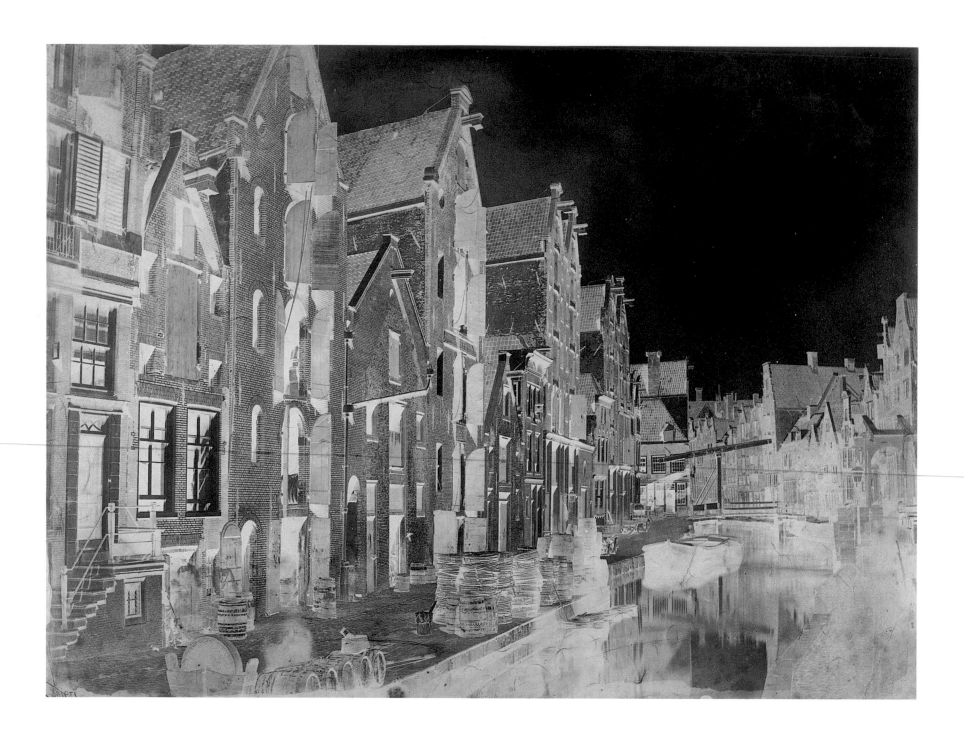

21 *View in Amsterdam* [former Nieuwezijds Achterburgwal, by the Hekelveld, now Spuistraat]

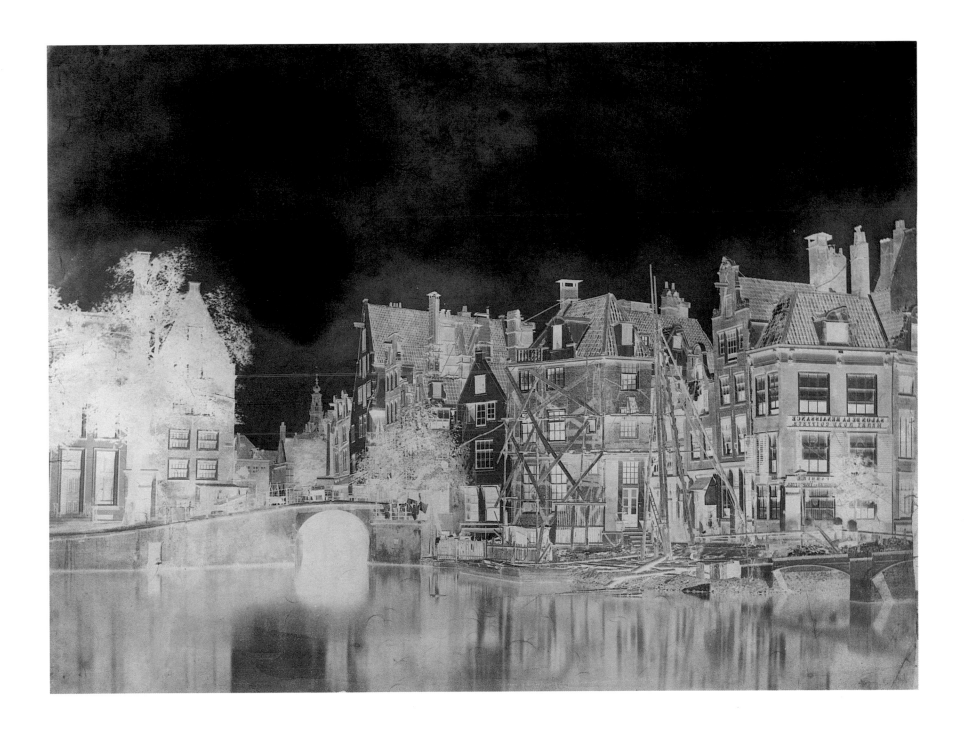

22 *View in Amsterdam* [Rokin near the Grimnessesluis with the Zuiderkerk]

23 *The Willowsway, Elfords, Hawkhurst*

24 *Scotch Firs, Hawkhurst*

25 *Near Hawkhurst Church, Kent*

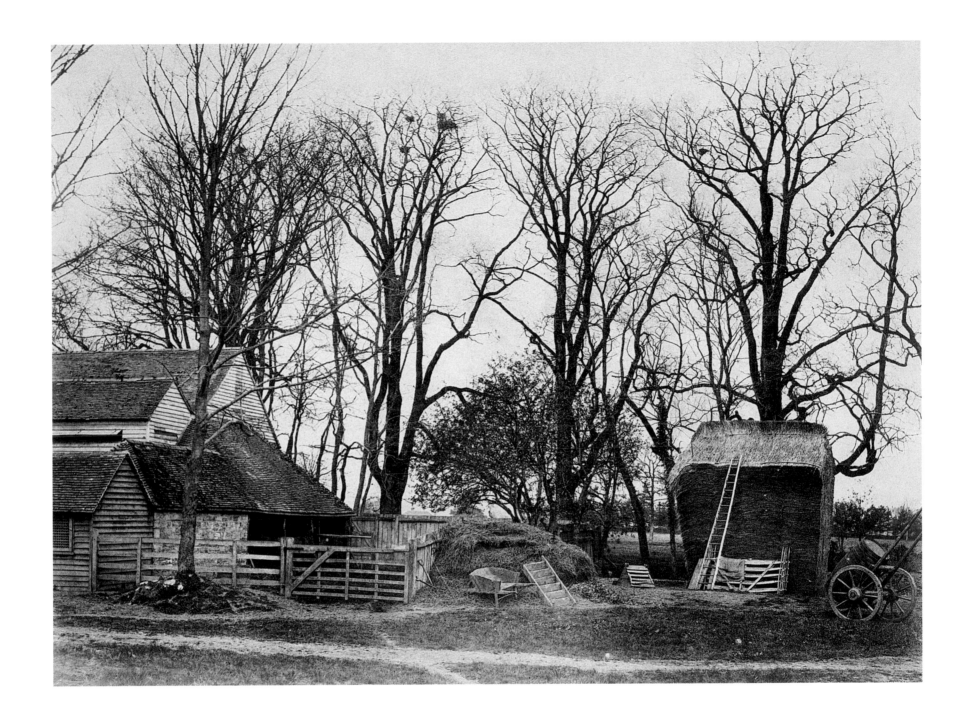

26 *Farmyard, Elfords, Hawkhurst*

27 *Hawkhurst Church, Kent*

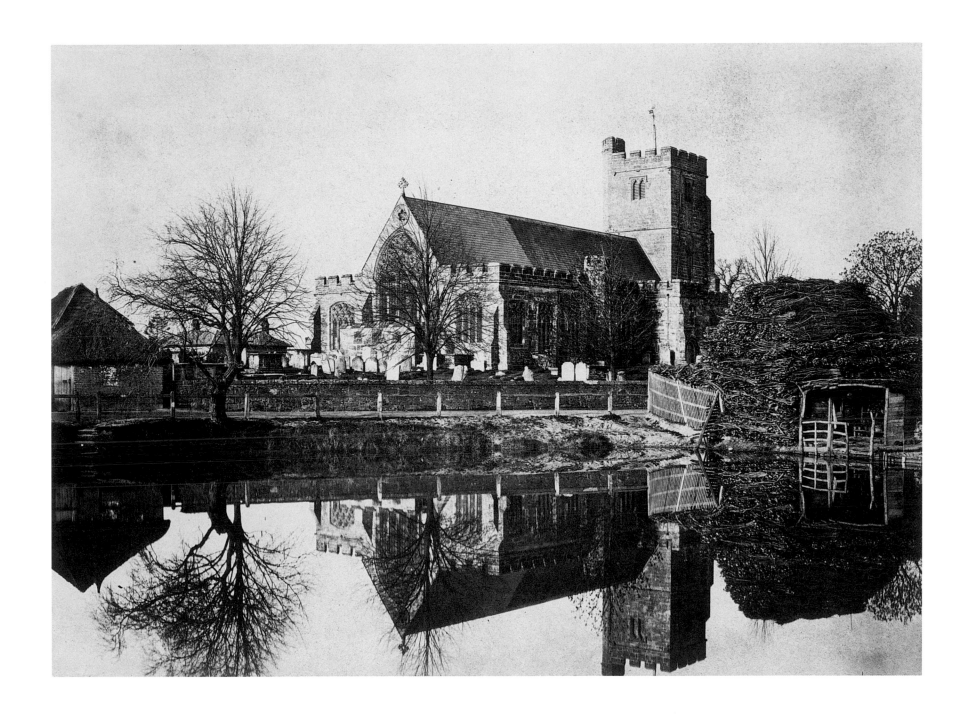

28 *Hawkhurst Church, Kent*

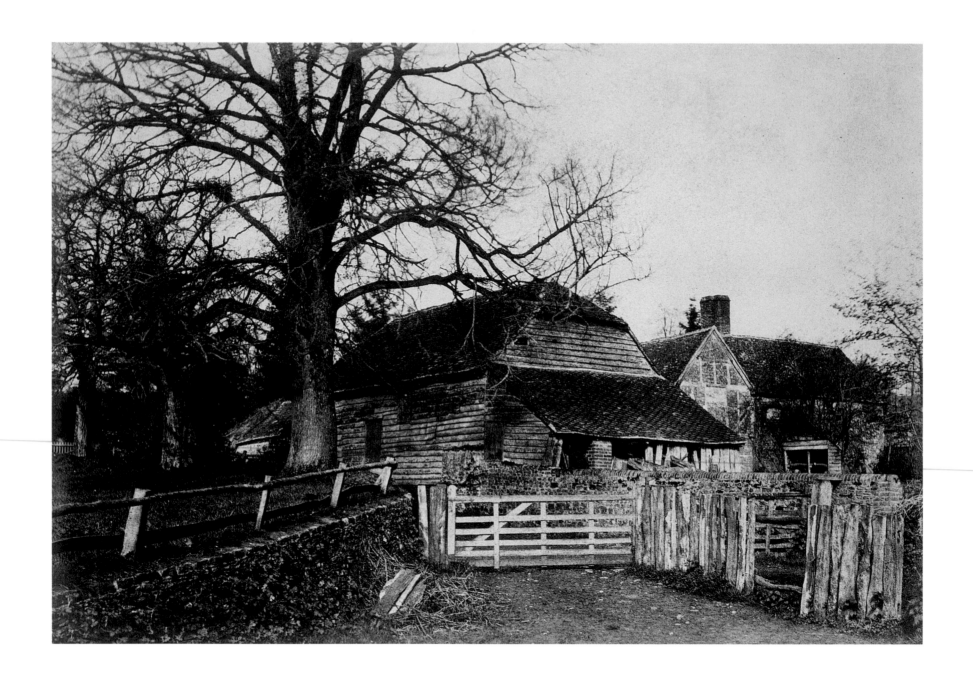

29 *At Compton, Surrey*

30 *Eashing Bridge, Surrey*

31 *Pepperharrow* [sic] *Park, Surrey*

32 *At Compton, Surrey*

33 *Hurtmore Lane, Surrey*

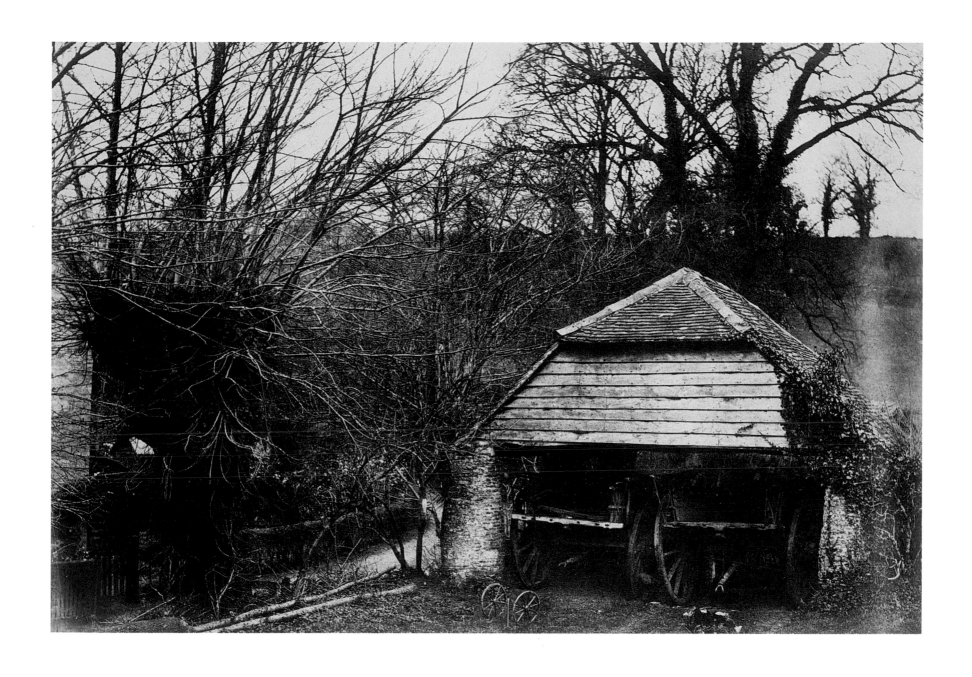

34 *Hurtmore Lane, Surrey*

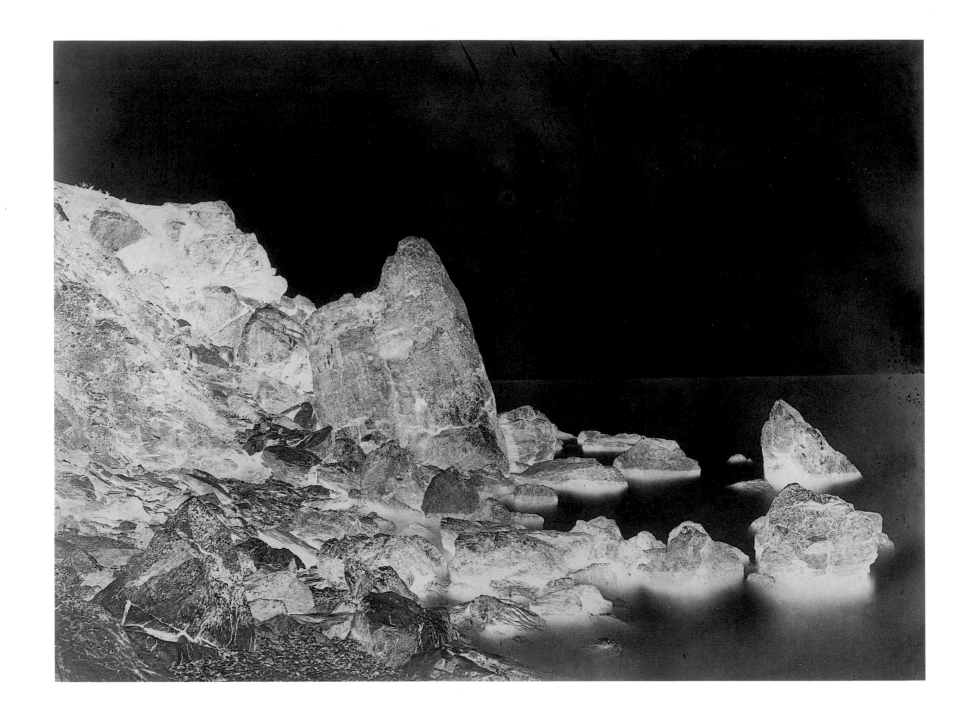

35 *Torquay*

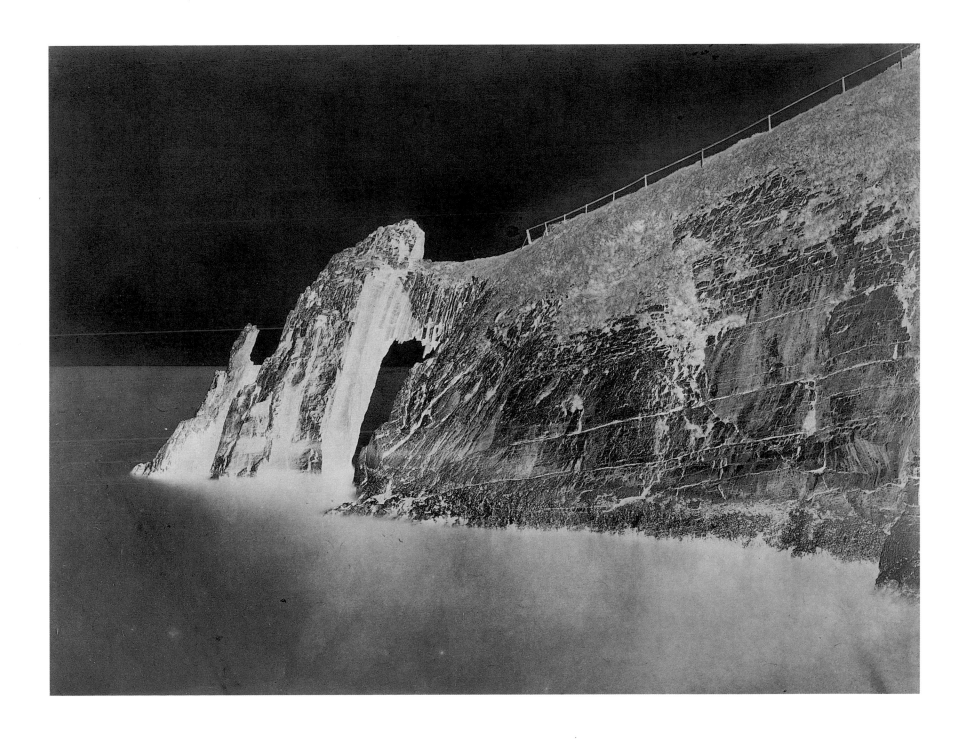

36 *Torquay*

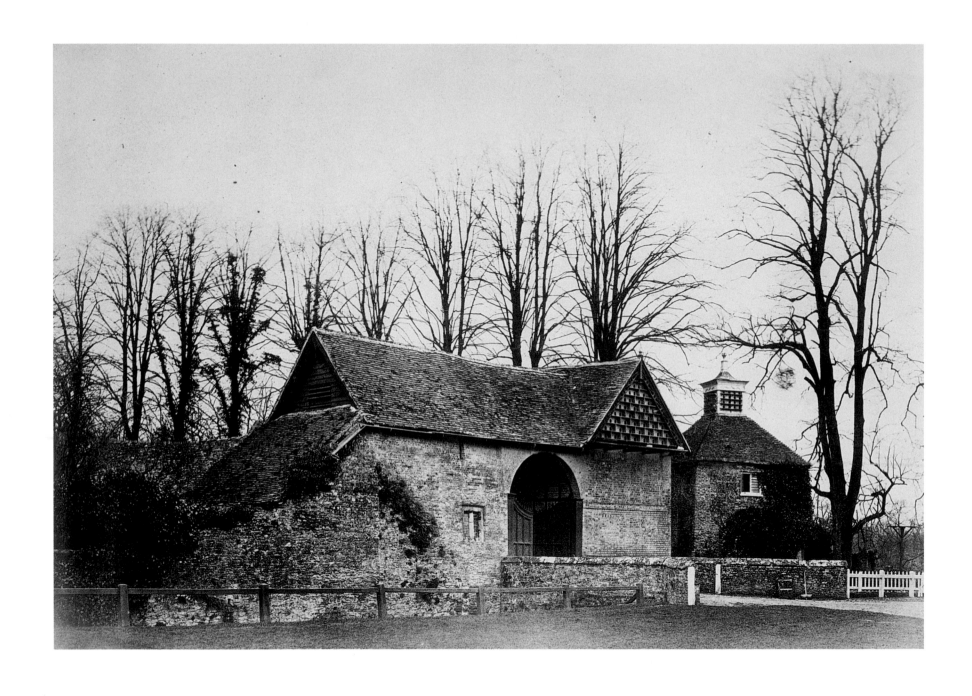

37 *Entrance Gateway, Losely* [sic] *House*

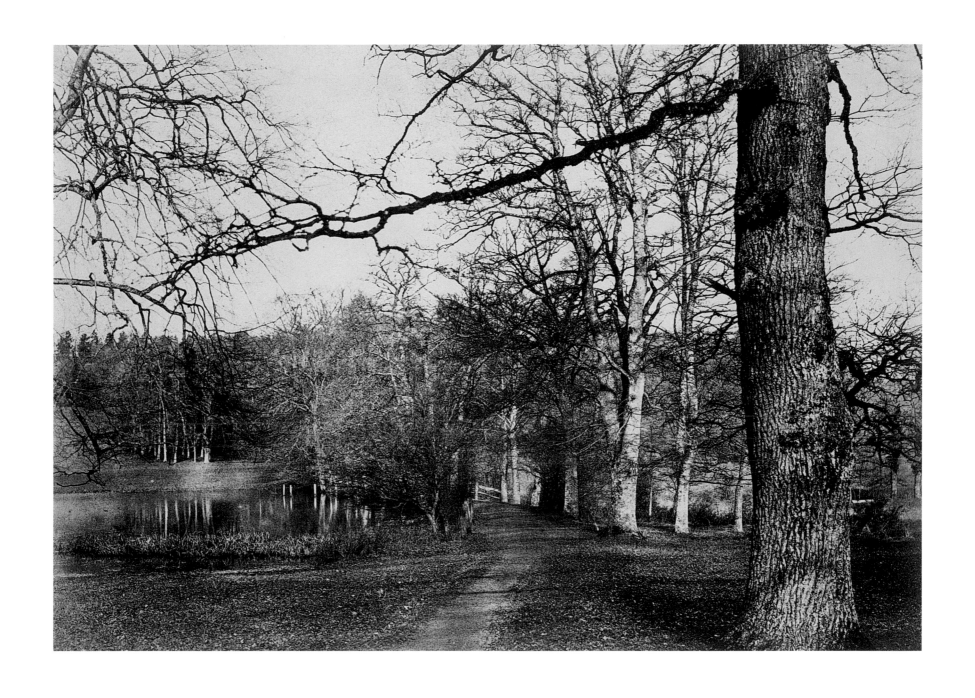

38 *Causeway, Head of the Lake, Losely [sic] Park*

39　*North Side of Quadrangle, Arundel Castle*

40 *Canterbury Cathedral*

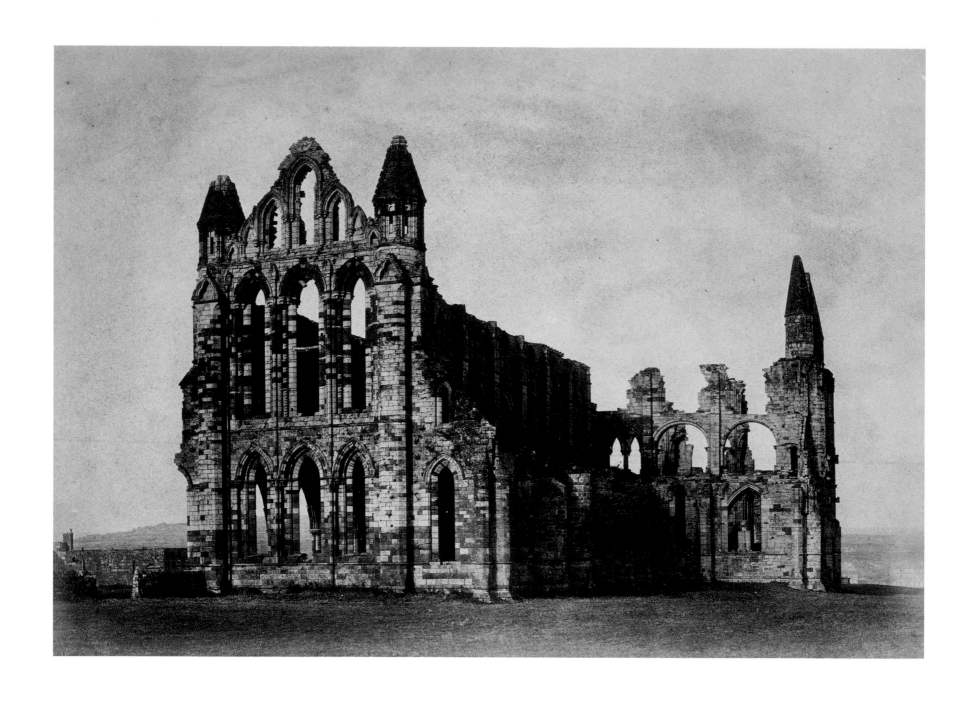

41 *Whitby Abbey, Yorkshire, from the North East*

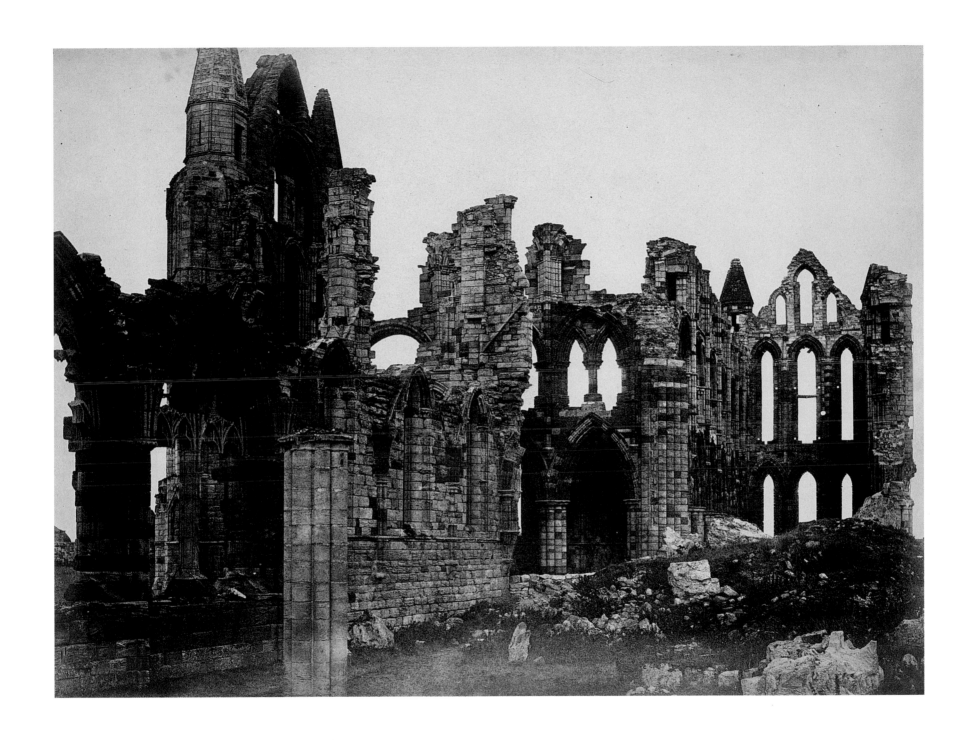

42 *Whitby Abbey, Yorkshire, Interior*

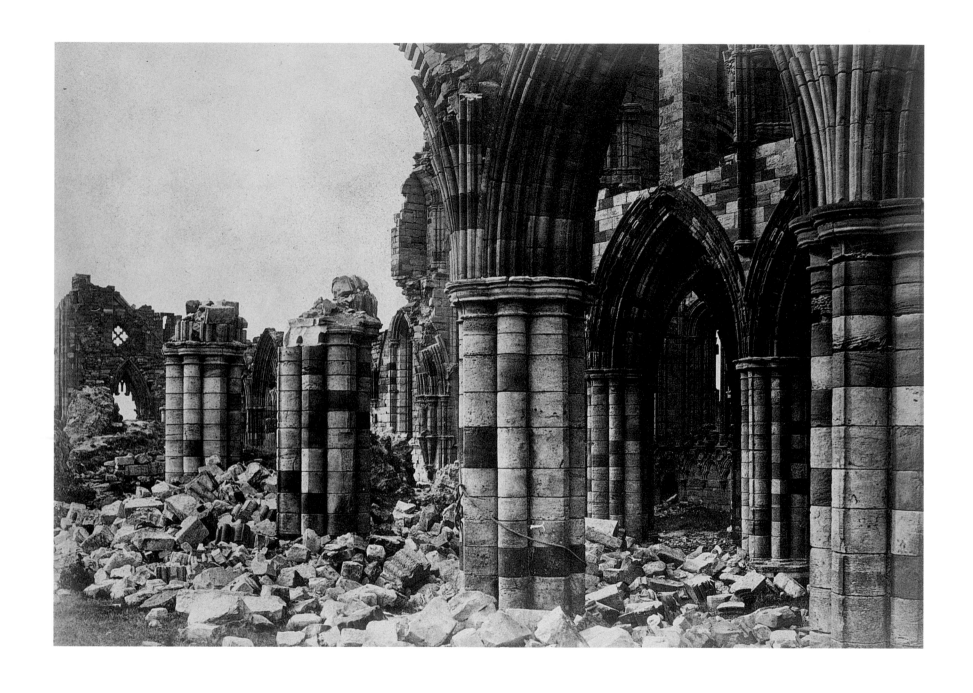

43 *Whitby Abbey, Yorkshire, Site of Central Tower*

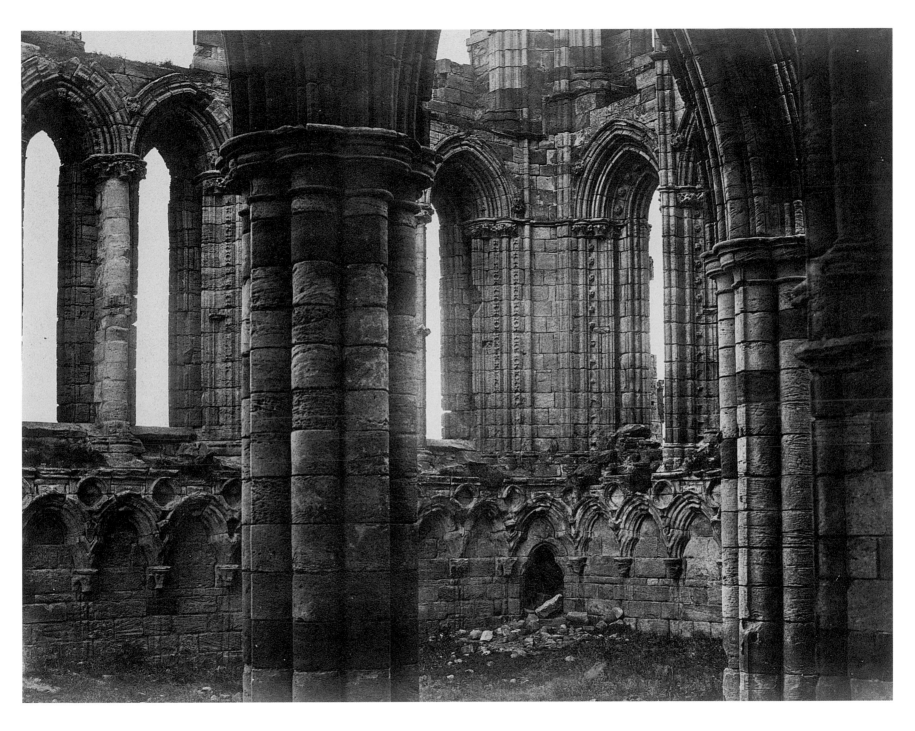

44 *Whitby Abbey, Yorkshire, North Transept*

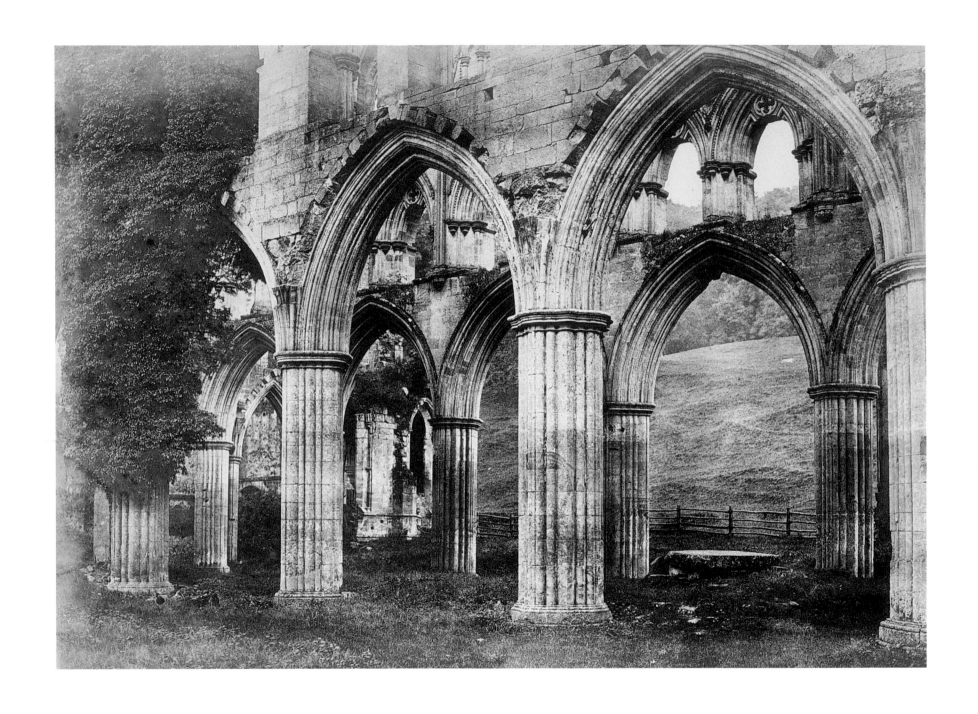

45 *Rivaulx* [sic] *Abbey, Yorkshire*

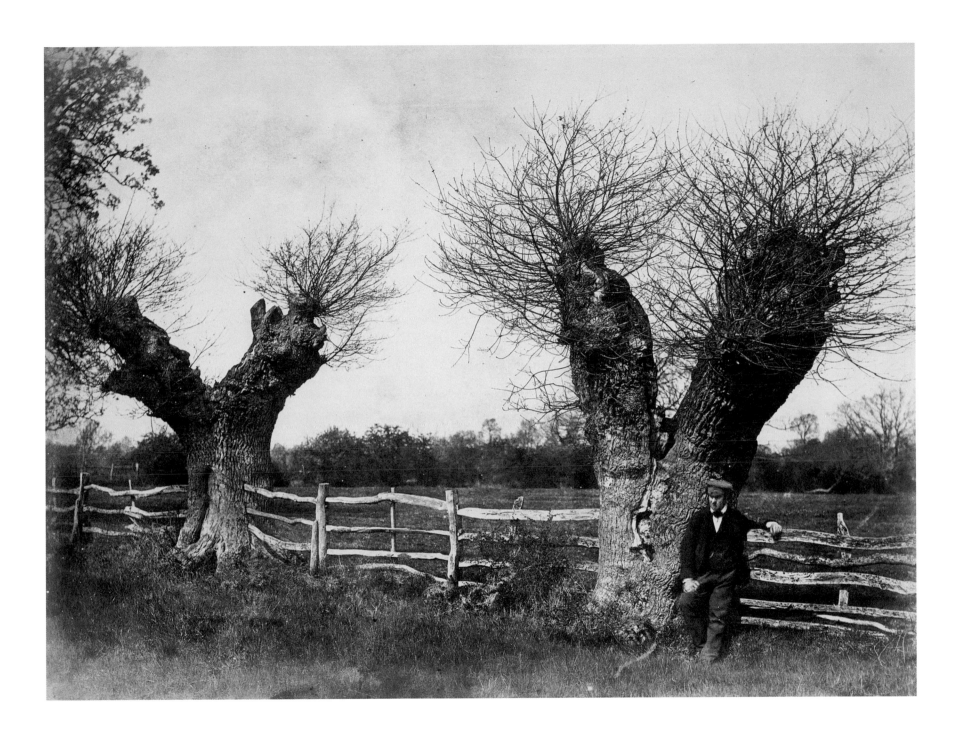

46 *Hedgerow Trees, Clerkenleap, Worcestershire*

List of Plates

The plates contain 39 of the 60 positive photographs which Turner compiled in *Photographic Views from Nature*. They do not retain the same sequence in which he arranged them. A list of Turner's original arrangement can be found in his contents page reproduced in fig. 21. One of the photographs, *Canterbury Cathedral* (pl. 40), is from the collection of the Metropolitan Museum of Art, New York, and does not appear in Turner's album. The remaining photographs are original paper negatives, which were also not part of the album. Negatives were occasionally exhibited in the 1850s as works of art in their own right. It is in this spirit that they appear here to show the range of Turner's subjects where no positive prints, or only poor quality examples, were known to exist.

All photographs listed are by Benjamin Brecknell Turner. Titles in italics are those given by Turner; those in the regular font are descriptive and appear in square brackets, e.g. [former Nieuwezijds Achterburgwal, by the Hekelveld, now Spuistraat]. Spellings and place names follow those used by Turner. Dimensions refer to the image size, height preceding width.
V&A = Victoria and Albert Museum, London.

1. *Crystal Palace, Hyde Park, 1852, Transept*, 1852
Albumen print from calotype negative
10⅜ × 15⁹⁄₁₆ in (26.3 × 39.5 cm)
V&A, Ph.1-1982

2. *Crystal Palace, Hyde Park, 1852, Nave*, 1852
Albumen print from calotype negative
10½ × 15¼ in (26.7 × 38.8 cm)
V&A, Ph.2-1982
For the New York exhibition, the print is lent from the Collection of JGS, Inc.

3. *Lynmouth, North Devon*, 1852-4
Albumen print from calotype negative
10½ × 15¼ in (26.7 × 38.7 cm)
V&A, Ph.3-1982

4. *Lyndale, North Devon*, 1852
Albumen print from calotype negative
10½ × 15⅜ in (26.7 × 39.1 cm)
V&A, Ph.4-1982

5. *Bredicot, Worcestershire*, 1852-4
Albumen print from calotype negative
10¼ × 15¼ in (26 × 38.7 cm)
V&A, Ph.16-1982

6. *Bredicot Court, Worcestershire*, 1852-4
Salted paper print from calotype negative
10½ × 15¼ in (26.7 × 38.8 cm)
V&A, Ph.22-1982

7. *Bredicot, Worcestershire*, 1852-4
Albumen print from calotype negative
10⅜ × 15⅜ in (26.3 × 39 cm)
V&A, Ph.20-1982

8. *Foldyard, Bredicot Court, Worcestershire*, 1852-4
Albumen print from calotype negative
10⁵⁄₁₆ × 15 in (26.2 × 38.1 cm)
V&A, Ph.23-1982

9. *Bredicot, Worcestershire*, 1852-4
Albumen print from calotype negative
10⅜ × 15³⁄₁₆ in (26.4 × 38.5)
V&A, Ph.18-1982

10. *Bredicot, Worcestershire*, 1852-4
Albumen print from calotype negative
10⅝ × 15¼ in (27 × 38.8 cm)
V&A, Ph.19-1982

11. *Cottage, Bredicot Common, Worcestershire*, 1852-4
Albumen print from calotype negative
11⅝ × 15⅝ in (29.6 × 39.6 cm)
V&A, Ph.21-1982

12. *Crowle Court, Worcestershire*, c. 1862
Calotype negative, waxed
11¹¹⁄₁₆ × 15¹³⁄₁₆ in (29.7 × 40.1 cm)
The Royal Photographic Society, Bath, England, 17856/122

13. *Gateway, Cathedral Yard, Peterborough*, 1852-4
Albumen print from calotype negative
10⁹⁄₁₆ × 15⁵⁄₁₆ in (26.8 × 38.9 cm)
V&A, Ph.5-1982

14. *Ludlow*, 1852-4
Albumen print from calotype negative
11⁹⁄₁₆ × 15½ in (29.4 × 39.4 cm)
V&A, Ph.25-1982

15. *Ludlow Castle, from the Tiltyard*, 1852-4
Albumen print from calotype negative
10⅜ × 15 in (26.4 × 38.1 cm)
V&A, Ph.27-1982

16. *Ludlow Castle, from the Tiltyard*, 1852-4
Albumen print from calotype negative
11¹¹⁄₁₆ × 15⅝ in (29.7 × 39.6 cm)
V&A, Ph.28-1982

17. *Ludlow Castle, Causeway and Entrance*, 1852-4
Albumen print from calotype negative
11⅝ × 15⅜ in (29.6 × 39 cm)
V&A, Ph.29-1982

18. *Ludlow Castle, Doorway of Round Church*, 1852-4
Albumen print from calotype negative
10⅜ × 15⅛ in (26.3 × 38.4 cm)
V&A, Ph.30-1982

19. *Abbey Church, Pershore, Worcestershire*, 1852-4
Albumen print from calotype negative
11⅜ × 15¼ in (28.9 × 38.8 cm)
V&A, Ph.8-1982

20. *Windmill, Kempsey, Worcestershire*, 1852-4
Albumen print from calotype negative
10⁹⁄₁₆ × 15⁵⁄₁₆ in (26.8 × 38.9 cm)
V&A, Ph.10-1982

21. *View in Amsterdam* [former Nieuwezijds Achterburgwal, by the Hekelveld, now Spuistraat], 1857
Calotype negative, waxed
11¾ × 15¹¹⁄₁₆ in (29.8 × 39.8 cm)
The Royal Photographic Society, Bath, England, 17916

22. *View in Amsterdam* [Rokin near the Grimnessesluis with the Zuiderkerk], 1857
Calotype negative, waxed
11¾ × 15¹¹⁄₁₆ in (29.8 × 39.8 cm)
The Royal Photographic Society, Bath, England, 17906

23. *The Willowsway, Elfords, Hawkhurst*, 1852-4
Albumen print from calotype negative
10½ × 15⅛ in (26.7 × 38.4 cm)
V&A, Ph.58-1982

24. *Scotch Firs, Hawkhurst*, 1852
Albumen print from calotype negative
10½ × 15 in (26.7 × 38.2 cm)
V&A, Ph.59-1982

25. *Near Hawkhurst Church, Kent*, 1852-4
Albumen print from calotype negative
10¾ × 15⁷⁄₁₆ in (27.3 × 39.2 cm)
V&A, Ph.55-1982

26. *Farmyard, Elfords, Hawkhurst*, 1852-4
Albumen print from calotype negative
10½ × 14³⁄₁₆ in (26.6 × 36.1 cm)
V&A, Ph.57-1982

27. *Hawkhurst Church, Kent*, 1852
Calotype negative, waxed
11¾ × 15¹¹⁄₁₆ in (29.8 × 39.8 cm)
The Royal Photographic Society, Bath, England, 17930/136

28. *Hawkhurst Church, Kent*, 1852-4
Albumen print from calotype negative
10¼ × 14¼ in (26.1 × 36.2 cm)
V&A, Ph.54-1982

29. *At Compton, Surrey*, 1852-4
Albumen print from calotype negative
10⅜ × 15⅛ in (26.3 × 38.4 cm)
V&A, Ph.33-1982

30. *Eashing Bridge, Surrey*, 1852-4
Albumen print from calotype negative
10⁹⁄₁₆ × 15⅛ in (26.9 × 38.4 cm)
V&A, Ph.32-1982

31. *Pepperharrow* [sic] *Park, Surrey*, 1852-4
Albumen print from calotype negative
10½ × 15¼ in (26.7 × 38.8 cm)
V&A, Ph.37-1982

32. *At Compton, Surrey*, 1852-4
Albumen print from calotype negative
10⅝ × 15³⁄₁₆ in (27 × 38.6 cm)
V&A, Ph.34-1982

33. *Hurtmore Lane, Surrey*, 1852-4
Albumen print from calotype negative
10¼ × 14¹⁵⁄₁₆ in (26.1 × 37.9 cm)
V&A, Ph.36-1982

34. *Hurtmore Lane, Surrey*, 1852-4
Albumen print from calotype negative
10¼ × 15³⁄₁₆ in (26.1 × 38.5 cm)
V&A, Ph.35-1982

35. *Torquay* [Ansty's Cove], c. 1862
Calotype negative, waxed
11¹¹⁄₁₆ × 15¹³⁄₁₆ in (29.7 × 40.1 cm)
The Royal Photographic Society, Bath, England, 17841/94

36. *Torquay* ['London Bridge'], c. 1862
Calotype negative, waxed
11¹¹⁄₁₆ × 15¹³⁄₁₆ in (29.7 × 40.1 cm)
The Royal Photographic Society, Bath, England, 17846/105

37. *Entrance Gateway, Losely*[sic] *House*, 1852-4
Albumen print from calotype negative
10⁹⁄₁₆ × 15¼ in (26.9 × 38.8 cm)
V&A, Ph.39-1982

38. *Causeway, Head of the Lake, Losely* [sic] *Park*, 1852-4
Albumen print from calotype negative
10⅝ × 15¼ in (27 × 38.8 cm)
V&A, Ph.41-1982

39. *North Side of Quadrangle, Arundel Castle*, 1852-4
Albumen print from calotype negative
10¼ × 15 in (26.1 × 38 cm)
V&A, Ph.44-1982

40. *Canterbury Cathedral*, c. 1859
Albumen print from calotype negative
11⁷⁄₁₆ × 15½ in (29.1 × 39.3 cm)
Metropolitan Museum of Art, New York, Edward Pearce Casey Fund, 1986, 1986.1045

41. *Whitby Abbey, Yorkshire, from the North East*, 1852-4
Albumen print from calotype negative
10½ × 15 in (26.6 × 38.2 cm)
V&A, Ph.47-1982

42. *Whitby Abbey, Yorkshire, Interior*, 1852-4
Albumen print from calotype negative
11⁷⁄₁₆ × 15 ½ in (29 × 39.3 cm)
V&A, Ph.49-1982

43. *Whitby Abbey, Yorkshire, Site of Central Tower*, 1852-4
Albumen print from calotype negative
10⁹⁄₁₆ × 15¼ in (26.9 × 38.8 cm)
V&A, Ph.50-1982

44. *Whitby Abbey, Yorkshire, North Transept*, 1852-4
Albumen print from calotype negative
10½ × 13⁹⁄₁₆ in (26.6 × 34.4 cm)
V&A, Ph.52-1982

45. *Rivaulx* [sic] *Abbey, Yorkshire*, 1852-4
Albumen print from calotype negative
10¹⁵⁄₁₆ × 15 in (27.8 × 39 cm)
V&A, Ph.46-1982

46. *Hedgerow Trees, Clerkenleap, Worcestershire*, 1852-4
Albumen print from calotype negative
11⁵⁄₁₆ × 15¼ in (28.8 × 38.8 cm)
V&A, Ph.13-1982

Glossary of Photographic Processes and Techniques

For further details see: Gordon Baldwin, *Looking at Photographs: A Guide to Technical Terms* (Los Angeles and London, J. Paul Getty Museum/British Museum Press, 1991), and Brian Coe and Mark Haworth-Booth, *A Guide to Early Photographic Processes* (London, V&A, 1983).

Ambrotype

The process was introduced in 1851 and generally used for portraiture. The image was usually placed behind glass in a gilt-edged frame housed in a presentation case. It is essentially an underexposed collodion negative made on glass which is backed with a dark coating to make it appear as a positive image. Also known as collodion positive (see also Wet collodion negative).

Albumen print

The first glossy, coated photographic print. In general use c.1855-90. Thin paper was first coated with a mixture of whisked egg white and salt, then sensitised with silver nitrate. It was usually printed out in sunlight under the negative in a printing frame.

Calotype

The process for the making of paper negatives invented by William Henry Fox Talbot in 1840 and patented by him in 1841. Fine-quality writing paper was sensitised with potassium iodide and silver nitrate solutions and could be used damp for extra sensitivity in the camera. The negative was developed in a solution of gallic acid and silver nitrate.

Carbon print

A photographic process, used chiefly from c.1865 onwards, in which a light-sensitive layer of gelatine is mixed with carbon pigment and potassium dichromate, rather than the silver compound found in most photographic printing techniques. The silver compound in other prints makes them subject to fading, but its absence in the carbon process makes carbon prints permanent.

Daguerreotype

Named after the French inventor Louis Daguerre. A highly detailed image formed on a sheet of copper thinly plated with silver and then rendered light sensitive by a chemical reaction with iodine and bromide vapours. The vapour would only adhere to the silver particles affected by light. The image was developed by suspending it over heated mercury. Each daguerreotype is unique. The process was used from 1839 to about 1860.

Paper negative

A negative image made on light-sensitive paper used to print positive images. The paper negative was often waxed to obtain greater transparency. In Talbot's original calotype (or Talbotype) process the negative was generally waxed after exposure; another process invented in 1851 by Gustave Le Gray involved waxing the paper before exposure.

Salt print/salted-paper print

Paper made sensitive to light by treatment with a common salt solution and silver nitrate. Invented by William Henry Fox Talbot in 1840. The image is part of the paper and its fibres (rather than appearing on a coated surface). Largely superseded in the 1850s by the albumen print.

Stereograph/stereoscope

A stereograph is pair of images giving the appearance of a three-dimensional image when viewed through an optical viewing device called a stereoscope. Various types of stereoscopes were devised, including Sir Charles Wheatstone's reflecting stereoscope, Sir David Brewster's box-type stereoscope and Oliver Wendell Holmes's hand-held device. The vogue for stereo photography began in the 1850s and continued well into the twentieth century.

Talbotype

An alternative term for calotype.

Wet collodion negative

A sheet of glass hand-coated with a thin film of collodion (guncotton dissolved in ether) containing potassium iodide and sensitised on location with silver nitrate. The plate had to be exposed while still wet and developed immediately. The process, introduced in 1851 by Frederick Scott Archer, gave a high resolution of detail and dramatically cut exposure times.

Select Bibliography

Brettel, Richard, with Flukinger, Roy, Keeler, Nancy and Kilgore, Sydney Mallett, *Paper and Light. The Calotype in France and Great Britain, 1839-1870* (Boston and London, Kudos & Godine, in association with The Museum of Fine Arts, Houston and the Art Institute of Chicago, 1984).

Crary, Jonathan, *Techniques of the Observer: On vision and modernity in the nineteenth century* (Cambridge, Mass., and London, MIT Press, 1990).

Harvey, Nigel, *Old Farm Buildings* (Princes Risborough, Buckinghamshire, Shire Publications, 1997).

Haworth-Booth, Mark (ed.), *The Golden Age of British Photography 1839-1900* (New York, Aperture, 1984).

Kraus, Hans P., and Schaaf, Larry J., *The Pencil of Nature,* facsimile edition (New York, Hans P. Kraus, Jr, 1989).

Payne, Christine, *Toil and Plenty: Images of the Agricultural Landscape in England 1780-1890* (New Haven and London, Yale University Press, 1993).

Seiberling, Grace, and Bloore, Carolyn, *Amateurs: Photography and the Mid-Victorian Imagination* (Chicago and London, 1986).

Weaver, Mike (ed.), *British Photography in the Nineteenth Century: The Fine Art Tradition* (Cambridge and New York, Cambridge University Press, 1989).

Weaver, Mike, *The Photographic Art: Pictorial Traditions in Britain and America* (Edinburgh and London, The Scottish Arts Council and the Herbert Press, 1986).

Wilton, Andrew, and Lyles, Anne, *The Great Age of British Watercolours 1750-1880* (London and Munich, Royal Academy Arts and Prestel Verlag, 1993).

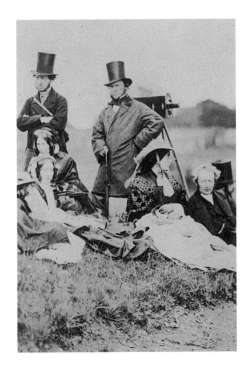

Detail of Turner from fig. 12

Principal Public Collections of Benjamin Brecknell Turner's work

Canadian Centre for Architecture, Montreal, Canada

Gemeentearchief [Municipal Archives], Amsterdam, The Netherlands

Gernsheim Collection, The Harry Ransom Humanities Research Center, University of Texas, Austin, U.S.A

J. Paul Getty Museum, Los Angeles, U.S.A.

National Gallery of Canada, Ottawa

National Museum of Photography Film and Television, Bradford, England

Rijksmuseum, Amsterdam, The Netherlands

Royal Antiquarian Society [housed at the Rijksmusem], Amsterdam, The Netherlands

Royal Photographic Society of Great Britain, Bath, England

Scottish Photography Archive, Scottish National Portrait Gallery, Edinburgh

Victoria and Albert Museum, London, England

Index

Page references in bold italics indicate illustrations